IMAGES
of America

CHIMNEY ROCK PARK
AND
HICKORY NUT GORGE

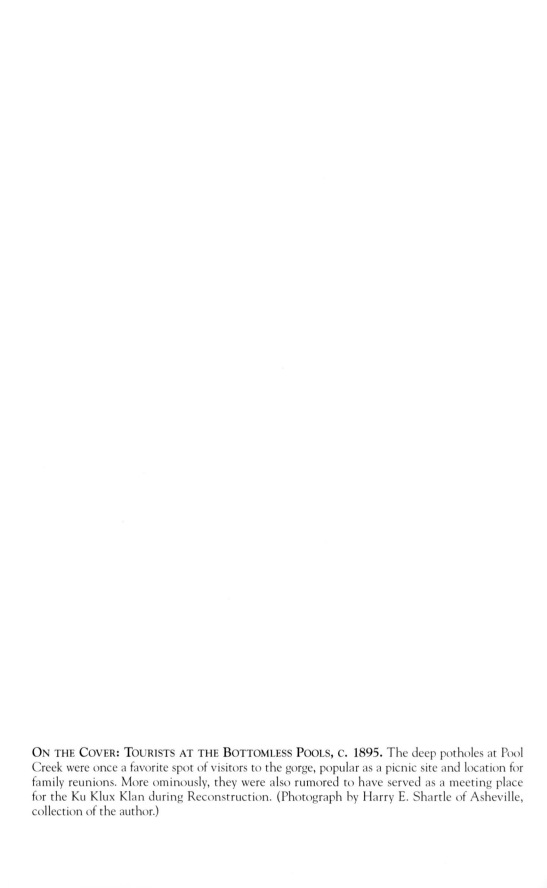

ON THE COVER: TOURISTS AT THE BOTTOMLESS POOLS, C. 1895. The deep potholes at Pool Creek were once a favorite spot of visitors to the gorge, popular as a picnic site and location for family reunions. More ominously, they were also rumored to have served as a meeting place for the Ku Klux Klan during Reconstruction. (Photograph by Harry E. Shartle of Asheville, collection of the author.)

IMAGES
of America

CHIMNEY ROCK PARK
AND
HICKORY NUT GORGE

J. Timothy Cole

ARCADIA
PUBLISHING

Published by Arcadia Publishing
Charleston, South Carolina

Printed in the United States of America

Library of Congress Catalog Card Number: 2007932430

For all general information contact Arcadia Publishing at:
Telephone 843-853-2070
Fax 843-853-0044
E-mail sales@arcadiapublishing.com
For customer service and orders:
Toll-Free 1-888-313-2665

Visit us on the Internet at www.arcadiapublishing.com

*To my mother, Helen Flack Cole, a native of Rutherfordton,
North Carolina, who has always loved Chimney Rock.*

CONTENTS

Acknowledgments 6

Introduction 7

1. Before the Park, 5 million BC–AD 1890 11

2. Early Park Development, 1890–1916 33

3. The Heyday of the Park's Development, 1916–1935 59

4. Along the Trails of the Park, 1910–1950 75

5. The Development of Lake Lure, 1923–1927 89

6. Inns and Camps, 1800–1950 99

Selected Bibliography 126

Index 127

ACKNOWLEDGMENTS

Unless otherwise indicated, all images herein are from the collection of the author. Institutions providing assistance included the following: the North Carolina Office of Archives and History, Raleigh, North Carolina; the Rare Book, Manuscript, and Special Collections Library, Duke University, Durham, North Carolina; the Wofford College Archives, Sandor Teszler Library, Spartanburg, South Carolina; and the North Carolina and Southern Historical Collections at Wilson Library, the University of North Carolina at Chapel Hill.

This book would not have been possible without the dedicated work of late-19th- and early-20th-century photographers such as Arthur F. Baker of Hendersonville; Herbert W. Pelton, Thomas H. Lindsey, W. T. Robertson, and Nat Taylor of Asheville; and many others whose work appeared especially on early postcards. These men could not have known how important their photographs would be to latter-day researchers of Western North Carolina's past.

As always, thanks are due to all my colleagues at Greensboro Public Library. Their kindness in accommodating my scheduling requirements helps me navigate that difficult compromise between research and gainful employment.

INTRODUCTION

The scenery of Hickory Nut Gorge (or Gap) is among the most breathtaking of the Blue Ridge and Western North Carolina, and its eastern extremity, where the villages of Chimney Rock, Bat Cave, and Lake Lure lie, is remarkable for its geological wonders and curious history. Here rise two great sentinels: Chimney Rock Mountain to the south and Round Top Mountain to the north, forming a portal or gateway to the Blue Ridge Mountains and beyond. Stupendous granite walls over 500 million years old, monuments to the seemingly timeless constancy of nature, surround the motorist who passes this way on U.S. Highway 74 along the Rocky Broad River.

But these rocks are not really timeless. It seems so only because geologic time passes so much more slowly than our own. The cliffs of the gorge are composed of a rock known to geologists as the Henderson Gneiss, and throughout are faults and closely spaced cracks called joints. During historic times, earthquakes occurred in the gorge, and it is possible that these quakes, as well as others extending back perhaps millions of years, help to explain the presence of the numerous faults. These cracks have in turn led to another process that geologists label "differential erosion," meaning the rock adjacent to the faults and cracks has become broken, and water and weathering have worn it away more easily than the surrounding rock. These three interrelated geologic processes—seismic activity, the presence of joints, and differential erosion—combine to account for many of the scenic wonders of the gorge.

The famous Chimney Rock is an excellent case in point. High up on Chimney Rock Mountain, this extraordinary 300-foot monolith looms above us like some man-made tower in the sky. A familiar landmark to many, Chimney Rock's peculiar shape leaves us with the sense that it is more than an accident of nature. But the separation of "the Chimney" from the mountain can easily be explained by differential erosion. Many millions of years ago, the Rocky Broad River was much higher than it is today, and it was just beginning to carve the gorge. The action of water—and subsequently weathering—eroded rock surrounding the monolith where joints had formed. Eventually Chimney Rock was created.

Though the existence of Native American artifacts in the Chimney Rock Valley is evidence of long-established human habitation, we know little of what the aborigines must have thought of this strange place. Only one legend has passed down to us, communicated by an old Cherokee chief of Qualla Town known variously as "All Bones" and "Flying Squirrel," who told the story of a young warrior who made his way eastward through the gap in search of tobacco, or *Tso-lungh*, but never returned. When a magician next volunteered for the trek to the tobacco country, he found the gorge guarded by spirits called "the Little People." The magician finally turned himself into a whirlwind, stripping the mountains of vegetation, scattering huge rocks, and frightening away these spirits. Ever afterward, the Cherokee had an abundant supply of tobacco, or so the legend has it.

Early in the 19th century, whites who had settled in the gorge witnessed an apparition of sorts, which suggests a basis for the Cherokee legend of the Little People. In September 1806, a newspaper article in the *Raleigh Register* (widely reprinted in papers across the country) recounted

an "Extraordinary Phenomenon" witnessed about Chimney Rock. Several members of the Reaves family and a man named Robert Searcy reported seeing "a very numerous crowd of beings resembling the human species . . . clad with brilliant white raiment . . . and collected about the top of Chimney Rock." Most likely, what they saw was a mirage-like, atmospheric phenomenon caused by temperature inversion, sometimes referred to as the *fata morgana*.

The first permanent white settlers probably occupied the gorge by the 1780s—as suggested by the establishment of Bill's Creek Baptist Church, about six miles from Chimney Rock, in 1785. According to Henry E. Colton, an old fort was still visible nearby as late as the 1850s. Around 1800, a large dwelling was constructed near Round Top, just east of the gap; this was later known as the Harris Tavern. It was a post office that also served stage traffic, which began to move between Rutherfordton and Asheville following completion of the Hickory Nut Gap Turnpike about 1830.

Occasionally, early travelers recorded their impressions of the gap. Among these was an Englishman, Charles Lanman (deserving credit, by the way, for preserving the Cherokee legend recounted above), who made his way through in 1848. In his *Letters from the Allegheny Mountains* (1849), Lanman described the gorge as "remarkably imposing" and in particular noticed the high bluff to the south at the entrance to the gap, rising almost perpendicular to a height of approximately 2,500 feet, and where "midway up its front stands an isolated rock, looming against the sky which is of a circular form, and resembles the principal turret of a stupendous castle." Here Lanman unmistakably describes Chimney Rock.

By the late 1850s, visitors were beginning to arrive in greater numbers; Henry Colton devotes an entire chapter to the gorge in his *Mountain Scenery* (1859), the first true travel guide to Western North Carolina. But soon came the interregnum of Civil War and Reconstruction. Union cavalry under Brig. Gen. William J. Palmer passed through the gap on their way to Rutherfordton from Asheville during Stoneman's famous raid of April 1865. (It is interesting that in peacetime, many years later, Palmer revisited the gap, staying at the famous Esmeralda Inn.) During Reconstruction, the gorge was regarded as a radical Republican stronghold, owing in part to Republican judge George W. Logan's ownership of the Harris Tavern, as well as to the tendency of the mountaineers in general to sympathize with the cause.

Brief notoriety came to the section during the spring of 1874, when a series of earthquakes occurred, centered on Bald Mountain (now known as Rumbling Bald). Locals thought the coincidence of the quakes with a religious revival (or "camp meeting") portended the end of the world; a newspaperman representing the faraway *New York Herald* wildly speculated that Bald Mountain might even be a volcano come to life. But the earthquakes did little damage—broken crockery and a tumbled chimney or two—and all the excitement soon died down. When the discovery of fissure caves on the side of Bald Mountain again attracted notice in 1878, at least one editor took a skeptical turn, characterizing the whole thing as a scheme to lure tourists.

Visitors began to trickle back during the 1870s and 1880s, including the writers Christian Reid and Frances Hodgson Burnett. But for most of the 19th century, Hickory Nut Gorge was a remote place with a few hard-scrabble farmers and only an occasional guest at the old Harris Tavern.

Though visitors must have surely been struck by its strangeness, Chimney Rock—that great monolith looming against the sky—could have only seemed a worthless "ten-acre rock" to most of the farmers toiling in the valley shadows below. Then, about 1887, a remarkable man, a Henderson County native, politician, and entrepreneur named Jerome Benjamin Freeman, came to the gorge, apparently to harvest timber from land owned by his father. And soon Freeman conceived of the idea of a stairway to Chimney Rock and the development of a park.

Chimney Rock and the surrounding acreage were then owned by a company formed in the late 18th century and referred to informally as "the Speculation Land Company." In the spring of 1890, "Rome" Freeman took the first steps to purchase this land and engaged a local carpenter named Daniel "Watt" Foster to build stairs to the monolith. Foster was the first human, so far as we know, to set foot on Chimney Rock; at the same time, Freeman also made a trail to the beautiful Hickory Nut Falls. By the summer of 1890, the stairway was completed and Freeman was charging a small fee to visitors willing to make the hour or so climb up Chimney Rock Mountain.

As a speculator, Jerome Freeman hoped a spur of the Seaboard Airline or some other railway would eventually be built through the gap, opening it up for tourism and real estate development. And when a Hendersonville physician and native of Illinois named Lucius Boardman Morse (along with his twin brothers) purchased Chimney Rock from Freeman in late 1902, he too hoped for a rail line. But it was not to be.

It took, finally, the coming of the automobile and highway improvements around 1915 to bring tourism to the Chimney Rock section on a large scale. This was the work of many men, including Dr. Morse, but it is perhaps John T. Patrick—a speculator best remembered today as the founder of the tourist town of Southern Pines—as well as North Carolina governor Locke Craig who most deserve credit for what amounted to Chimney Rock's transportation revolution.

Patrick, who had bought a great deal of land in the area, did much to stimulate road improvements in the section with his Good Road Days during the summer of 1913. Volunteers in Chimney Rock, Bat Cave, and elsewhere spent several days working on the roads and then celebrated their efforts with a big barbecue. Governor Craig (who had his own statewide Good Roads Days later that year) did his part by putting the power of his office behind the completion of the Charlotte to Asheville Highway, the most difficult section of which was the Hickory Nut Gap Road. African American chain gangs labored two years to finish it.

Responding to these transportation developments, Lucius Morse began planning improvements to Chimney Rock Park in 1915. The most important was the completion of the Chimney Rock Motor Road from the valley below to the base of Chimney Rock. This was finished by July 1916 and celebrated on a grand Fourth of July that year with the raising of the Stars and Stripes over Chimney Rock. Jerome Freeman, in attendance that day, could take satisfaction that his dreams for the park and the development of the section were finally being realized.

The gorge suffered severely from the great flood of 1916, which struck just two weeks after the grand opening of the motor road. But the flood proved to be only a temporary setback. Over the next few years, Dr. Morse made other additions and improvements in the park, including the Pavilion, a restaurant located immediately below Chimney Rock in 1918, and the Cliff Dweller's Clubhouse and Cottages during 1921 and 1922. Before the end of the summer of 1919, Morse had even trained electric spotlights upon the rock at night, creating a spectacular effect.

Tourists came, and then some. Traffic through the gorge increased exponentially over the period from about 1914—when road improvements first became significant—until the Depression ended the boom, about 1930. Park visitors were of course a big part of this, sometimes nearly doubling in a single year.

All these people had to stay somewhere when they came. Many camped out, but as Lucius Morse told an audience at a Good Roads meeting in 1915, "Yankees" want steam-heated hotels. At the time, the Esmeralda Inn, built in 1891 and located between Chimney Rock and Bat Cave, was probably the best known and most popular hotel in the area, especially among the movie companies that frequented Bat Cave during the second decade of the 20th century. But the Esmeralda was soon eclipsed by the Mountain View Inn, barely more than an oversized farmhouse until 1916. That year, owner J. Mills Flack laid a new foundation for a much larger hotel of 46 rooms. This rustic building would remain the area's principal hotel until its destruction by fire in 1956. Other important inns in the Chimney Rock section during the first half of the 20th century included the Rockwood Inn, Bat Cave Inn, Edney Inn, Logan Inn, and up on Sugar Loaf Mountain, the Salola Inn (also known as Clow's Dude Ranch).

Along with hotels also came summer camps for boys and girls. The first of these was probably Camp Minnehaha for girls (established 1912); other girls' camps in the area were Camp Suwali (1922) and the Lake Lure Camp for Girls (1928). Probably the best known summer camp was the Chimney Rock Camp for Boys (1917). Operated for many years on the shores of Lake Lure by a Florida man named Reese Combs, the camp continues to have a magnetic effect on visitors, owing to the filming there in 1986 of the popular movie Dirty Dancing.

After Dr. Morse completed the Cliff Dweller's project, he turned his attentions to a much grander scheme: the damming of the Rocky Broad River to create a scenic and recreational lake, which

his wife named Lake Lure. By late 1923, Chimney Rock Mountains, Inc., had been chartered, and early the next year thousands of acres were purchased and work on the lake begun. The dam project was completed by 1927. Morse foresaw the development of a huge resort community with many hotels, residential subdivisions, recreational facilities, and so on—a playground for the newly affluent of the booming 1920s. But the stock market crash of 1929 brought an end to these dreams; by 1930, Chimney Rock Mountains, Inc., had gone into foreclosure.

The Depression closed the most important period in the history of the gorge. There were further improvements for the park, such as the construction of a new entrance during 1934 and 1935 and the completion of the elevator in 1949. And during World War II, Lake Lure played an important role as a rest center for troops from the European theater. In more recent decades, the filming of movies, such as *Last of the Mohicans*, has cast a spotlight on the area. But it was during the period from about 1890 to 1927 that the essential developments took place: Chimney Rock Park, Lake Lure, and the blossoming of the tourist trade.

With the State of North Carolina's recent acquisition of the park, as well as nearby tracts on Rumbling Bald and at World's Edge, the dawn of a new day, in which access and conservation will be more thoughtfully balanced, may hopefully be on the horizon.

One

BEFORE THE PARK
5 MILLION BC–AD 1890

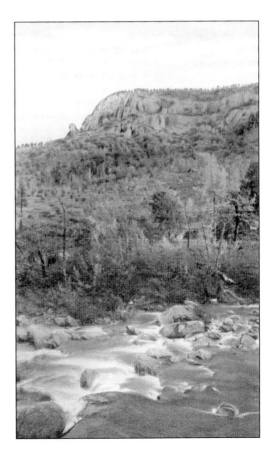

ROCKY BROAD RIVER AND CLIFFS, C. 1920.
University of North Carolina at Charlotte
geologist James F. Matthews relates that the
rocky cliffs of Hickory Nut Gorge—made
of what is called the Henderson Gneiss
(pronounced "nice")—were formed deep
beneath the Earth's crust over 500 million
years ago. Through a process of differential
erosion upon cracks and fissures in the
rock, the river has slowly carved the gorge.

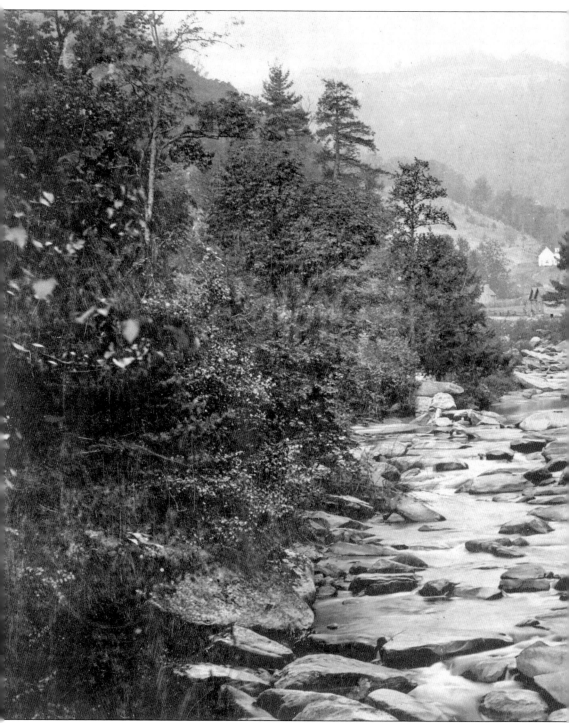

ROCKY BROAD RIVER, C. 1895. In this unusual view, photographer Thomas H. Lindsey of Asheville looks to the west toward the village of Bat Cave. The Bat Cave Baptist Church, organized in 1892, can be distinguished in the distance (center). Here the modern road forks, and U.S. Highway 64 leading to Edneyville and Hendersonville passes right in front of the church. This old structure

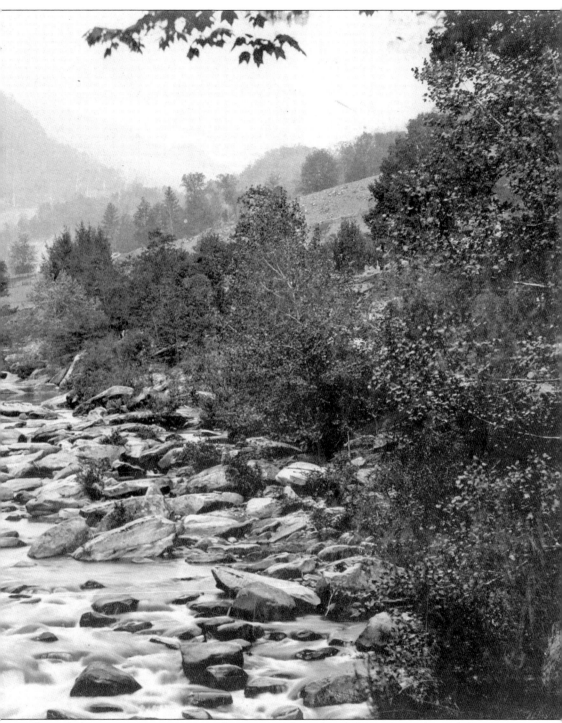

still stands (its congregation now attends a more modern church located just above it), but from this vantage today it would be obscured by trees. On the hillside to the church's left is a graveyard where many of the Bat Cave section's old families lie buried, bearing names like Hudgins, Duvall, Sumner, Freeman, and Dodson.

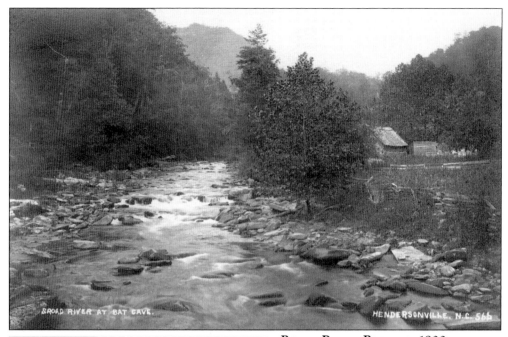

BROAD RIVER AT BAT CAVE.

HENDERSONVILLE, N.C. 566

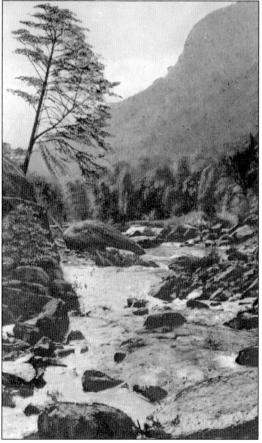

ROCKY BROAD RIVER, C. 1900 AND 1920. The appearance of the river has changed over the years. In his column in a Bat Cave community newsletter in 1997, old-timer Bud Sumner wrote that "the Rocky Broad River was not always as rocky as it is today. Prior to the flood of 1916, the river contained rocks that were smaller and not so numerous." The great flood, the effects of which are shown below, brought mud slides and many huge boulders into the river from the cliffs above. Compare the river rocks in the two photographs. With its history of floods and tectonic activity, Hickory Nut Gorge displays perhaps more clearly than most places the punctuation of gradual geologic processes by sudden catastrophe.

ROCKY BROAD RIVER, C. 1870. This rather cluttered riverbank photograph was part of a series produced and sold by the New York firm of E. and H. T. Anthony, a popular seller of stereographic images during this period. The identity of the mountain in the background is unclear. Those in this series were probably the first photographs made of the Hickory Nut Gorge area.

NORTH-CAROLINA.

RALEIGH, (N. C.) SEPT. 15.

Extraordinary Phenomenon.—The following phenomenon, that appeared to a number of people in the couty of Rutherford, state of North Carolina, was made on the 7th of August, 1806, in presence of David Dickie, Esq. of the county and state aforesaid, Jesse Anderson and the Rev. George Newton, of the county of Buncombe, and Miss Betsey Newton of the state of Georgia, who unanimously agreed with the consent of the relators that Mr. Newton should communicate it to Mr. J. Gales, Editor of the Raleigh Register and State Gazette

"EXTRAORDINARY PHENOMENON," 1806. The Chimney Rock section first attracted widespread notice when a strange atmospheric phenomenon—probably the *fata morgana*, a mirage resulting from temperature inversion—was witnessed near the cliffs of Chimney Rock Mountain. Ghostlike apparitions briefly appeared to dance about the cliff side; depositions were taken and reported to the *Raleigh Register*.

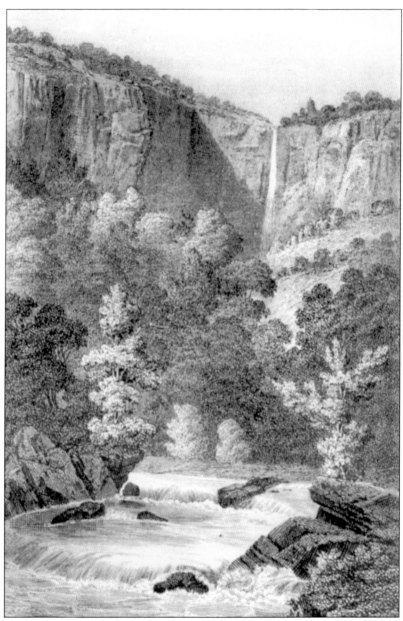

HICKORY NUT FALLS, C. 1859. This engraving of the spectacular waterfall on Chimney Rock Mountain is from an early Western North Carolina travel guide, Henry E. Colton's *Mountain Scenery*. Colton was literally awestruck by the gorge's natural beauty. "But a few miles beyond Rutherfordton, the grand prospect bursts upon vision," he wrote of the approach to the gorge from the east. "The Pinnacle, Sugar-Loaf, Chimney-Rock, Tryon Mountain, with innumerable other peaks, loom up over the horizon, and stretch from the north to the west and south, as far as the eye can reach. It is but for a moment, for the scene vanishes behind the intervening forests. . . . At last the hills recede a little, leaving a kind of basin of some hundreds of acres. This is Harris's, or Chimney-Rock House, a place of considerable resort. . . . To the southwest, about a mile distant, is Chimney-Rock Mountain, so called from a huge rock standing out from its side in the form of a chimney."

16

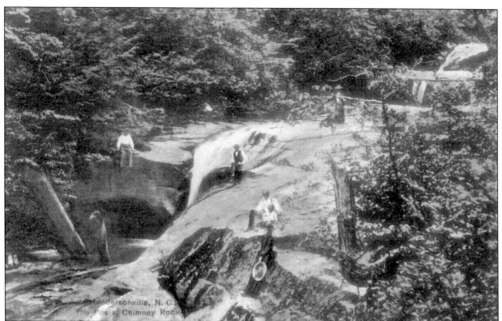

BOTTOMLESS POOLS, C. 1910–1920.
The Bottomless Pools are very deep
potholes that occur in Pool Creek,
located in the valley east of Chimney
Rock Mountain not far from the Lake
Lure Administration Building. In the
above photograph, it appears that tree
trunks have been used to measure their
depths. In his *Western North Carolina
Sketches*, Rutherford County historian
Clarence Griffin maintained that the
Bottomless Pools had been a meeting
place for the Ku Klux Klan, which was
active in Rutherford County during
Reconstruction. This tradition may be
more legend than fact, but the pools
were definitely a popular destination
for summer visitors during the late
19th and early 20th centuries.

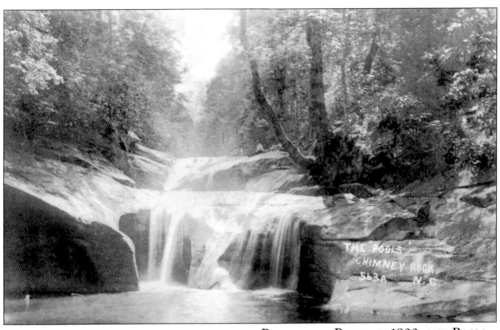

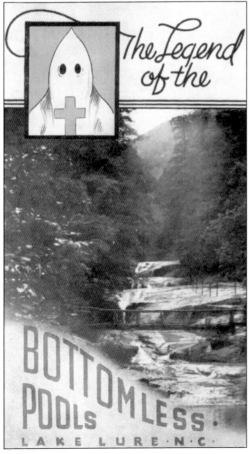

BOTTOMLESS POOLS, C. 1900, AND POOLS BROCHURE, C. 1940. The above photograph was probably taken by Hendersonville's Arthur F. Baker (1857–1936). Similar images were widely reprinted on early-20th-century postcards. Lee Powers (1899–1993), a local real estate developer, purchased the Bottomless Pools during the Depression. In the segregated South of the Jim Crow era, the racist Klan was in many quarters an object of veneration, and the local legend that connected the place to that organization was nothing of which to be ashamed. "The dark, opaque waters," a brochure averred, "are ever silent about the awesome rites of the Ku Klux Klan . . . which did so much to restore the South from the horrors of Reconstruction."

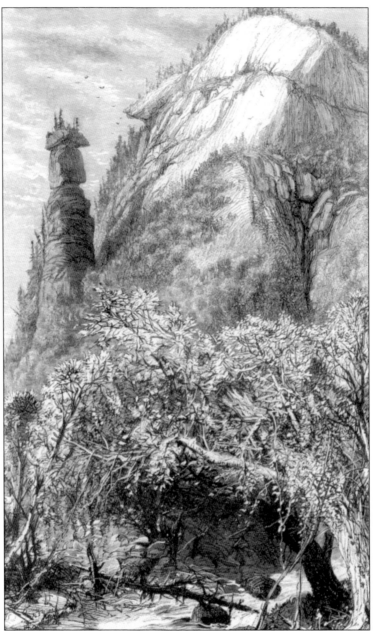

ENGRAVING, CHIMNEY ROCK, C. 1870. This engraving, based on a painting by Harry Fenn, was published in 1872 in the well-known and sumptuously illustrated two-volume *Picturesque America*, edited by poet William Cullen Bryant. Note the trees growing on the top of the monolith, which up to that time had not been ascended by man. The image is, to say the least, fanciful: the Chimney Rock monolith is seemingly balanced upon a pillar of rock that does not exist. The same engraving earlier appeared in an 1870 issue of the then-popular magazine *Appleton's*, with accompanying text by Henry E. Colton. Colton regarded the monolith as "one of Nature's most wonderful freaks." He wrote, "If my traveler is disposed to theorize with Agassiz [a noted geologist of the time], he may find ample food for the query, 'Whence came that somber pile? What tore it from its neighboring mountain-cliff?'"

CHIMNEY ROCK SECTION, C. 1870. The stereograph above shows Chimney Rock Mountain from the road in front of the Harris Tavern. Hickory Nut Falls is just visible on the cliffs to the right. The old Harris place was essentially the center of the community, serving as the local post office, a stagecoach stop, and a hotel for travelers visiting the region. So it was perhaps only natural that a photographer of the period would have stopped here. The Hickory Nut Gap Turnpike, built about 1830, went right past the hotel. Harris Tavern still stands on Boys Camp Road but is bypassed by the current highway. Pictured below is a scene on the Rocky Broad River. Both of these images were part of the above noted stereograph series produced and sold by the New York firm of E. and H. T. Anthony.

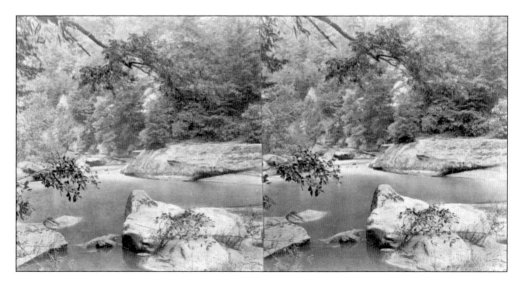

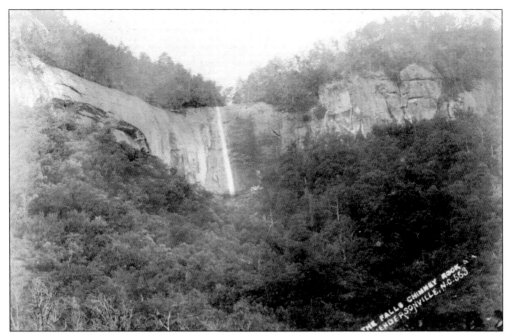

HICKORY NUT FALLS, C. 1900. This waterfall, located on the side of Chimney Rock Mountain, can rightly be considered among the finest in Western North Carolina, dropping vertically more than 400 feet down the mountainside. Visitors to the park can reach the falls by J. B. Freeman's old cliff side trail, which he called the Appian Way, and also by the mountaintop Skyline Trail.

GORGE ENTRANCE, C. 1900. To the left is Chimney Rock Mountain, and to the right is Round Top Mountain. Tourism played only a modest role in the region's economy until the late 19th century. Most of the families there made a living from agriculture. In the foreground is rich bottomland near the river—the choice farmland. Those who worked the mountainsides were mere subsistence farmers.

RUMBLING BALD MOUNTAIN, C. 1930. National attention came to the area in the spring of 1874, when Rumbling Bald, located to the east of Round Top and then known only as Bald Mountain, became associated with a series of mild to moderate earthquakes. According to most reports, the tremors began on February 10th and probably continued at least until June; some of them were felt and heard 17 miles away in Rutherfordton. The first of these earthquakes coincided with a religious revival or camp meeting on Bald Mountain, and locals thought they portended "the day of jubilee was at hand." Newsmen were sent to investigate, and their reports included many colorful anecdotes about illicit distillers and other mountain characters.

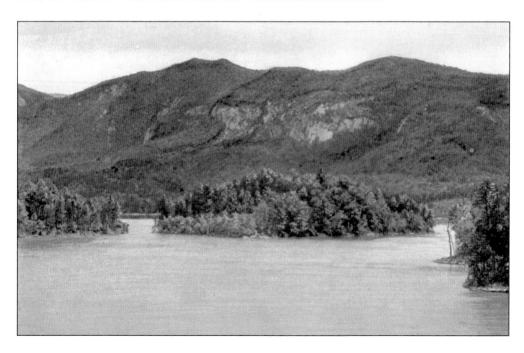

OUR VESUVIUS.

Bald Mountain Quaking and Smoking—Rustic Terror—Illicit Distillers Fleeing from the Wrath to Come—Pentecostal Penitence and "All Things in Common."

[Correspondence New York Herald.]

THE VOLCANIC REGIONS, McDOWELL COUNTY, N.C., March 20, 1874.

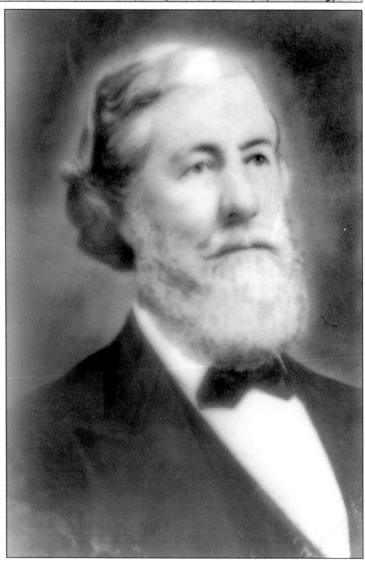

"OUR VESUVIUS," 1874, AND WARREN DUPRE, C. 1875. Dr. Warren Dupre (right), a natural sciences professor at Spartanburg's Wofford College, accompanied by students, made a trek to the Chimney Rock section to investigate while the quakes were under way. *New York Herald* reporter J. P. Cowardin interviewed him and conveyed the erroneous impression that Bald Mountain might well be a volcano! It is difficult to say whether all the confusion owed more to the yellow journalism of the day, the reporter's ignorance, or the infant science of geology's (and hence the professor's) only vague understanding of seismic phenomena. All these factors seemed to play a role. (Right, Wofford College Archives.)

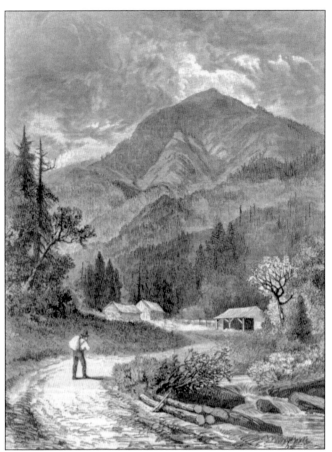

ENGRAVINGS, CHIMNEY ROCK SECTION, 1874. These engravings, created by an artist for *Harper's Weekly*, accompanied an article of April 11, 1874, describing the Bald Mountain earthquakes. The quakes generated a tall tale or two, mostly in a humorous vein. For instance, spotting smoke and fire seemingly coming from Bald Mountain, the *New York Herald* reporter was said to have donned protective attire—including pots and pans—and trudged up the mountainside thinking he would find a volcano. Instead, he discovered that a local farmer was merely burning grass. The story may have been concocted to poke fun at the reporter's gullibility in thinking Bald Mountain a volcano.

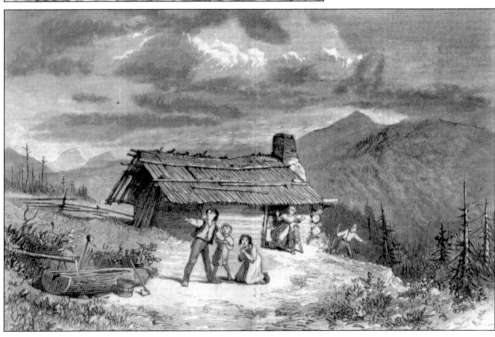

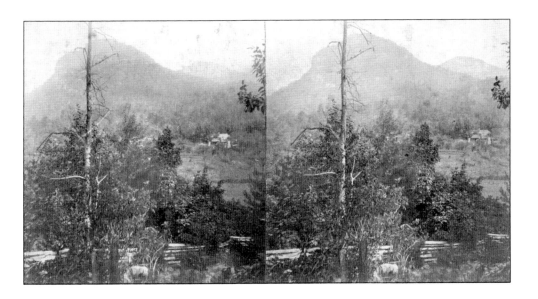

STEREOGRAPHS, C. 1870. Compare these images with the *Harper's Weekly* engravings on the preceding page. Pictured above is another Anthony stereograph, in this instance of Round Top Mountain, taken near the Harris Tavern; below is an image of Hickory Nut Mountain, also by Anthony. Although Hickory Nut Mountain is not located in Hickory Nut Gap, it seems reasonable to conclude that the *Harper's Weekly* artist confused the two and used it as well as the photograph of Round Top to inspire his own depictions of the gorge at the time of the earthquakes. Accurate information about a remote place like Hickory Nut Gap would have been rather difficult to obtain in 1874. Perhaps the *Harper's* artist paid a visit to E. and H. T. Anthony's New York storefront to obtain images of the Chimney Rock section.

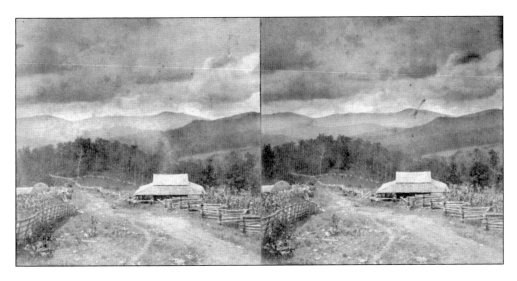

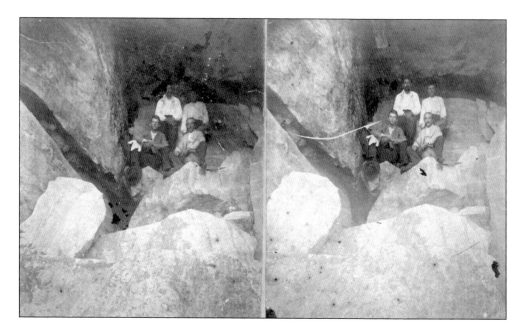

BALD MOUNTAIN "SPLIT," C. 1878, AND RUMBLING CAVES, C. 1880. The above stereograph of "the split" in Bald Mountain was made by Asheville photographer W. T. Robertson. The mountain again attracted attention in 1878 when a large crack and fissure caves were discovered in its rocky southern wall. The seated man, lower right, is probably J. Mills Flack, the young proprietor of the Chimney Rock Hotel (as the old Harris Tavern was known at the time). The image below, depicting the entrance to the Rumbling Caves, was sold by Taylor and Engle of Asheville. The caves were explored by members of the Speleological Society of Washington, D.C. (later the National Speleological Society) in July 1940, led by William J. Stephenson. They have also been explored and studied by local cavers in more recent years.

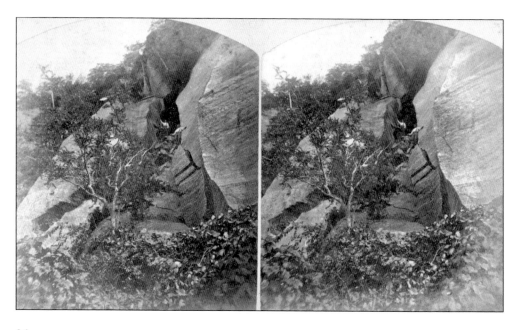

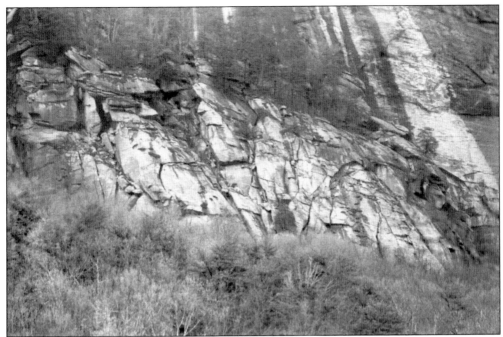

FISSURES, RUMBLING BALD. Cracks are evident in this recent photograph of the south side of the mountain. These cracks must be at least partly due to seismic activity. Though relatively mild compared to earthquakes such as those in California, the Bald Mountain quakes were significant for the East Coast. They may also have had some relationship to the great Charleston earthquake of 1886.

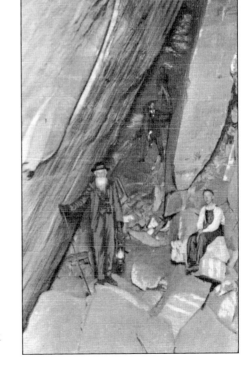

RUMBLING CAVES, C. 1925. Though identified as Bat Cave, this image is rather believed to be a view of the Rumbling Caves. The old man holding the lantern is once again J. M. Flack, by then the owner of the Mountain View Inn. Flack frequently served as a guide to the area's caves.

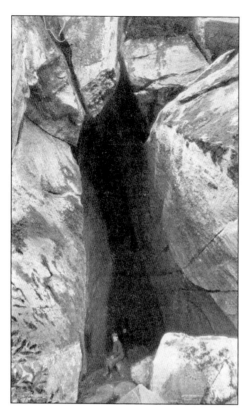

BIG BAT CAVE, C. 1920. Like the Rumbling Caves, the Bat Caves are also "fissure" caves, caused by earth movements. The chamber just beyond the main entrance to the Big Bat—"the Cathedral"—is quite impressive, the ceiling soaring some 85 feet with boulders balanced at its apex. The Bat Caves are part of a system of fissure caves thought to be one of the largest of this type in the world.

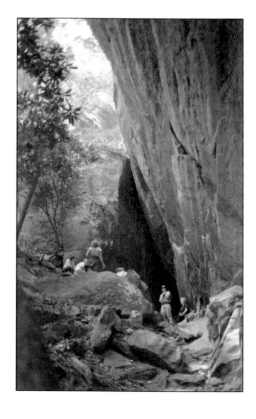

LITTLE BAT CAVE, C. 1987. The Little Bat lacks an impressive entrance, but just a short distance inside is a very deep pit. Early-20th-century traveler Roland F. Holloway described how upon entering it a gust of cool air blew out his party's torches; much to their horror, they learned a rock could be tossed "against the opposite wall and then [heard] bouncing down and down into chambers below."

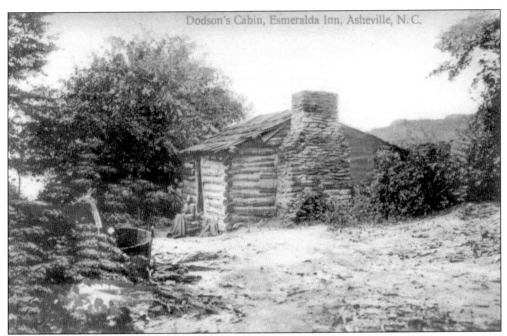

Dodson's Cabin, Esmeralda Inn, Asheville, N.C.

DODSON'S (OR DOTSON'S) CABIN, C. 1920. About 1880, one of the authors of an interesting Western North Carolina travel guide of that era, Zeigler and Grosscup's *Heart of the Alleghenies*, was guided to the Bat Caves by a man he referred to only as "Dotson." Remote "lost tribe" communities near Bat Cave and Chimney Rock were living in crude cabins such as the one pictured here well into the 20th century.

OLD MAN'S FACE, C. 1890. This feature, located on the south side of Rumbling Bald Mountain, is associated with a local folk tale of patricide. Nearby is another rock formation named Esmeralda's Cabin. Prominent 19th-century author Frances Hodgson Burnett is believed to have written her popular drama *Esmeralda* while vacationing at the old Harris Tavern.

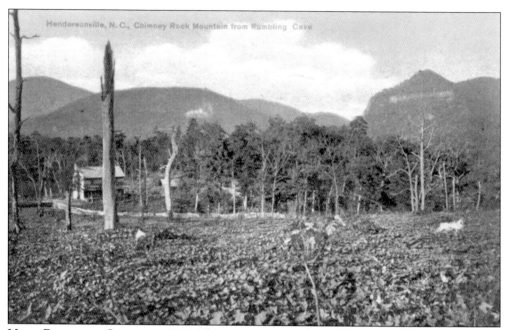

NEAR RUMBLING CAVES, C. 1910. The vantage point shown here is to the south, taking in Chimney Rock Mountain and Round Top. The Rumbling Caves were a popular destination for tourists in the late 19th and early 20th centuries but are rarely visited today. However, Rumbling Bald has recently (in 2005) been acquired by the State of North Carolina and will soon be transformed into a state park.

CHIMNEY ROCK, C. 1889. Taken by Asheville photographer Thomas H. Lindsey, this view may predate the first ascent of Chimney Rock, since it also appears in a guidebook he published in 1890 that makes no mention of the monolith being accessible. An earlier Asheville photographer, Nat Taylor, identified Chimney Rock as the subject of one of his stereographs (about 1880), but no image has been located.

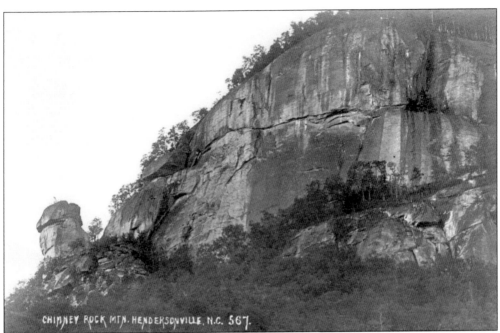

CHIMNEY ROCK MTN. HENDERSONVILLE, N.C. 567.

CHIMNEY ROCK MOUNTAIN, C. 1900.
Prominent Hendersonville photographer
Arthur F. Baker took the above view
from the valley below Chimney Rock;
it is probably a very early image, but
the exact date is unclear. Again by
Baker, the wintertime view below takes
in some of the buildings located in
the valley. Both of these photographs
may be contemporaneous with or
even predate a trip Baker made to
Hickory Nut Gap when he learned of
Jerome Freeman's work on Chimney
Rock Park and made what is regarded
as the first close-up photograph of
the monolith (see chapter two).

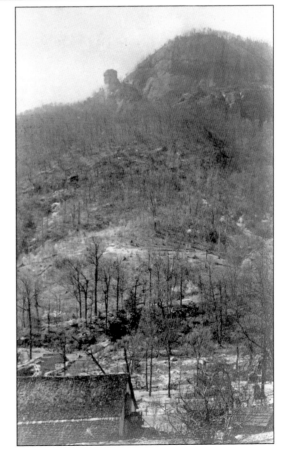

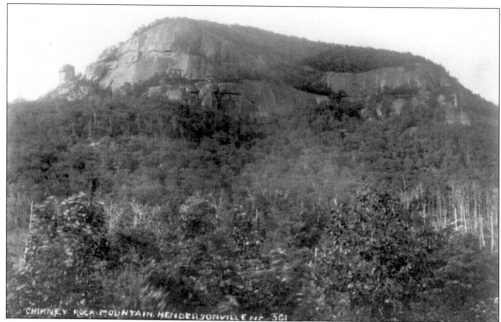

CHIMNEY ROCK MOUNTAIN, C. 1900. Once again attributed to A. F. Baker, this photograph captures the northern cliffs of Chimney Rock Mountain coursing from the monolith to Hickory Nut Falls, located just to the right and outside the field of view. The cliffs on this part of the mountain would form the nucleus of the park developed by Jerome Freeman.

ROUND TOP MOUNTAIN, C. 1910. In the late 1800s, Round Top was sometimes called "Vance's Nose" in honor of North Carolina governor and later senator Zebulon Baird Vance (1830–1894). A tale of lost Spanish gold is also associated with Round Top. Rutherford County's only Confederate general of the Civil War, Collett Leventhorpe, is said to have searched for it here.

Two

EARLY PARK
DEVELOPMENT
1890–1916

CHIMNEY ROCK, a solid mass of granite, stands 2,000 feet above the valley, 2,300 feet above sea level. The chimney itself is 225 feet high. The first ascent to the rock was made in 1887. It is 26 miles from Asheville along Wildcat Highway through Hickory Nut Gap to Chimney Rock Village, then three miles on Chimney Rock Motor Road. One of nature's wonders in America.

DESCRIPTION OF CHIMNEY ROCK, C. 1925. The chronology of the park's early history is muddled by conflicting sources. The above, from a souvenir postcard folder, implies that the stairway was completed in 1887. Under the Morses, Chimney Rock Park long advertised that the enterprise began in 1885. Jerome Freeman is variously said to have obtained the park's land from the Speculation Land Company in 1870 for $25 and 1880 for $400.

JEROME B. FREEMAN. J. B. "Rome" Freeman (1849–1919), with whom the idea of Chimney Rock Park originated, was a native of Henderson County. He resided there and in Buncombe County before removing to Bat Cave, probably about 1887. Freeman represented Henderson County as a Republican in the state legislature in 1897 and 1903 and is remembered as a bit of a showman and speculator. Though apparently largely self-educated, he was very intelligent. He avidly read history and enjoyed political debates. One of his obituaries described him as "tall and of magnificent physique, [one] of the very best type of Western North Carolina manhood." At his death, Freeman was applauded for the active interest he took in the establishment of the Fruitland Institute, a Baptist school located near Edneyville that still exists. His role in establishing Chimney Rock Park and helping develop the section should never be forgotten. But for J. B. Freeman, the whole history of Chimney Rock might have taken a very different turn. (Drawing by author.)

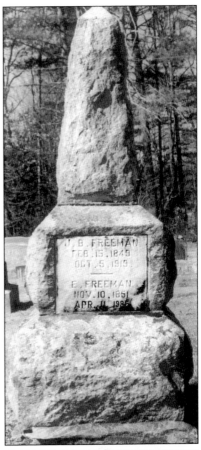

GRAVE OF JEROME B. FREEMAN. When Freeman died, the *Western North Carolina Times* of Hendersonville opined that he deserved "a suitable monument to perpetuate his memory . . . either at Fruitland or Chimney Rock—perhaps the latter place would be most suitable." Freeman has never been so honored, but his grave is marked by this interesting obelisk at Fruitland Cemetery. Next to him lies his father, Joseph Hawkins Freeman (1826–1898), who in his later years resided in the Bat Cave community on land he bought from the Speculation Land Company in 1871. The Freemans are an old and extended Henderson County family who has contributed much to the history and development of that place.

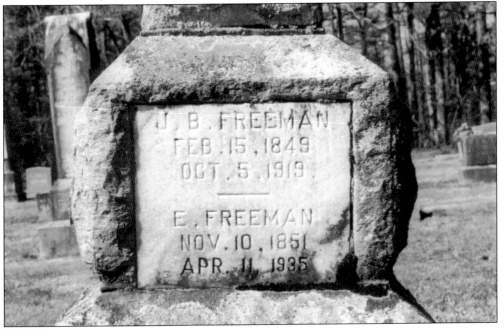

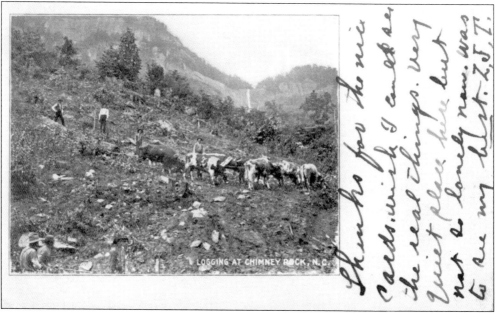

LOGGING, CHIMNEY ROCK MOUNTAIN, C. 1905. Logging first drew J. B. Freeman to Chimney Rock, and during his first few years in the section, Freeman is said to have occupied himself harvesting timber from the side of Chimney Rock Mountain, probably from his father's property. This may be a photograph of one of Freeman's ox-drawn logging teams.

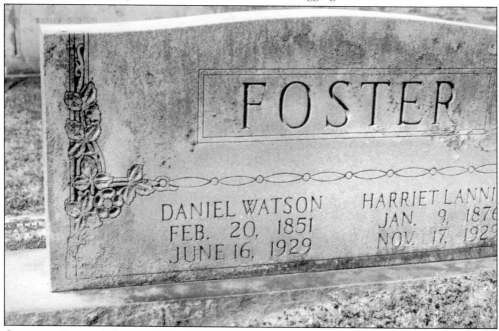

GRAVE OF DANIEL WATSON FOSTER. A carpenter who resided in the Chimney Rock section for many years, "Watt" Foster (1851–1929) was hired by Freeman to build the first stairway to the monolith. His account of the park's early development is preserved in a rare *c.* 1920 pamphlet titled *Chimney Rock Anthology* by a woman named Maude Ilsen. Foster is buried at the Chimney Rock Baptist Church.

Brevard N.C.

March 8 - 90

C. B. Justice

Dear Bro —

enclosed find check for $10 — Please send me Bond at once I will want the survey made in the Spring *yours Resp*

Jerome B Freeman
Hendersonville N.C.

LETTER FROM J. B. FREEMAN, 1890. With this brief note dated March 8, 1890, Freeman paid his deposit ($10) for the land that would become Chimney Rock Park. Though the note does not refer specifically to Chimney Rock, there can be little doubt that these are the lands concerned, for there are no other records of Speculation lands purchased by Freeman at this time. This is the earliest located documentation of his steps to acquire the property. Here he negotiates with C. B. Justice (whom he likely calls "Bro.," owing to the latter's prominence as a Baptist preacher), the local agent of the Speculation Land Company, to buy two tracts on Chimney Rock Mountain—one of 64 acres, the other of 67. The latter tract included the monolith and waterfall. Thus, 1890 seems to have been the park's first year. However, Freeman apparently took some years to pay for the property and did not gain clear title until 1896. (Southern Historical Collection, Wilson Library, University of North Carolina at Chapel Hill.)

An Agreemest, Made the *30* day of *January* 190*1*

between WILLIAM REDMOND, Jr., and FRANCIS M. SCOTT, surviving Trustees, of the first part, and *J F Gilliam* of the second part, as follows:

The parties of the first part for their heirs and assigns covenant and agree to and with the part *y* of the second part to sell to *himself* all that piece of land in the County of *McDowell* North Carolina *fifty acres part of Pat 1016 on the tributaries of Bush Branch adjoining the lands of H.L. Gilliam and his own to be surveyed in proper form*

for the consideration of *one $\frac{50}{100}$ dollars per acre* to be paid as hereinafter covenanted ; and that after the performance of said covenant by the part *y* of the second part, a good and sufficient deed in fee simple for the said lands excepting and reserving all mines, ores and minerals thereon, with the right to enter thereon to search for and work the same, shall be made to part of the second part, *his* heirs and assigns by WILLIAM REDMOND, JR., & FRANCIS M. SCOTT, surviving trustees for the heirs of Isaac Bronson, deceased, Goold Hoyt, deceased, Archibald McIntire, deceased, under a deed of trust to WILLIAM REDMOND, JR., ISAAC BRONSON and FRANCIS SCOTT, Trustees, of the City, County and State of New York, dated the 14th day of November, 1871, duly registered, or the survivor or survivors of them, and the part *y* of the second part agree $ to purchase said lands and pay the parties of the first part, their agent or attorney therefor the sum of *one $\frac{50}{100}$ dollars per acre* to be paid in *one* equal yearly payments, with interest annually from this date and to list and pay the taxes on said land hereafter. And in case default shall be made in payments of said sum of money, with the lawful interest, or either of them, it shall be lawful for the parties of the first part to enter on said lands and hold the same discharged from this agreement as fully as if it had not been made.

In Testimony Whereof, the parties have hereunto set their hands and seals the day and year first above written.

WM. REDMOND, JR., (Seal.) ⎫
 ⎬ Trustees.
FRANCIS M. SCOTT, (Seal.) ⎭

In the presence of

D. G. Clements

C B Justice NJ (L. S.)

..................................... (L. S.)

J F Gilliam (L. S.)

SPECULATION LAND AGREEMENT, C. 1900. Original deeds to the park have not been located, though court copies survive at the Rutherford County Courthouse. Freeman's agreement to purchase the land would have been made on a form similar to the one above. The Speculation Company lands were divided into very large patents; Freeman's tracts were part of Patent No. 1061. His agreement was not registered in Rutherford County until 1894; development of the park seems to have proceeded following the payment of his deposit in March 1890. There is also no mention of the Speculation Land Company in the agreement. Grantors of the land are identified as trustees of the estate of Isaac Bronson. The Speculation Company was formed in the late 18th century, and one of its principals was prominent Philadelphian Tench Coxe, who acquired huge land holdings in Western North Carolina; the lands subsequently passed to a number of trustees. The company continued granting patents well into the early 20th century.

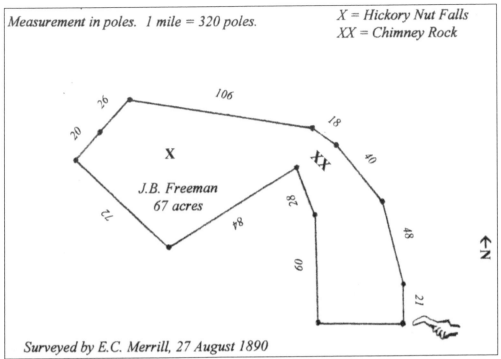

Measurement in poles. 1 mile = 320 poles.

X = Hickory Nut Falls
XX = Chimney Rock

26
20
106
18
X
40
XX
J.B. Freeman
67 acres
28
72
84
48
60
21
↑
N

Surveyed by E.C. Merrill, 27 August 1890

PARK LANDS, C. 1890. A man named E. C. Merril (or Merrill) surveyed Freeman's Speculation Company lands in August 1890. The southern tract, depicted here, included Chimney Rock and Hickory Nut Falls (locations approximate). The northern courses match exactly those of the 64-acre tract sold to Lucius B. Morse and his brothers in late 1902. (Plat reconstruction by author.)

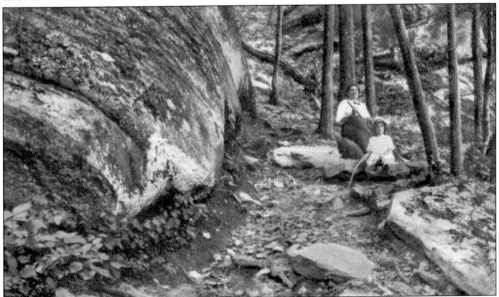

FOOTPATH, C. 1910. There was no road to the base of Chimney Rock in the early days of the park. Visitors had to walk or ride by mule on a trail made by Freeman's workmen. It took two to three hours to climb from the foot of the mountain to the top of Chimney Rock and back. If visitors also hiked to Hickory Nut Falls, the journey became virtually an all-day affair.

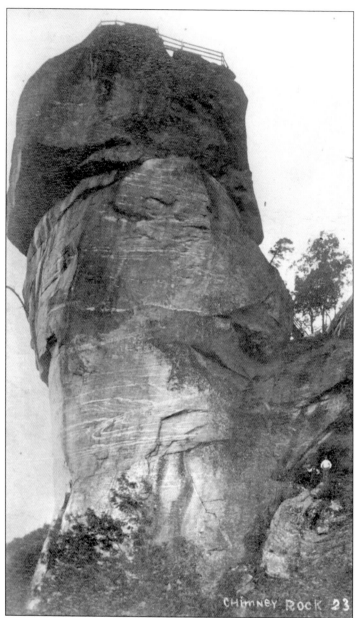

CHIMNEY ROCK, C. 1890. A July 1890 article in the *Asheville Citizen* refers to the "recently completed" stairway; when Freeman announced the sale of the park to the Morse brothers in January 1903, he told a reporter that the property had been purchased from the Speculation Land Company "twelve years before." Based on this and other documentation noted above, the park opening can be dated conclusively to 1890. Taken by A. F. Baker, this was probably the first photograph of the monolith made after the completion of the stairway. Henderson County historian Sadie Patton wrote that Baker made his way to the gorge when he learned that "Freeman was . . . engaged in building a stairway by which visitors might reach the mountain top." The image can definitely be dated no later than 1893. Below and to the right are two men, one pointing to a sign; though very difficult to read, scrutiny under high magnification suggests it could bear the word "SOLD." The taller man in the white shirt may be J. B. Freeman.

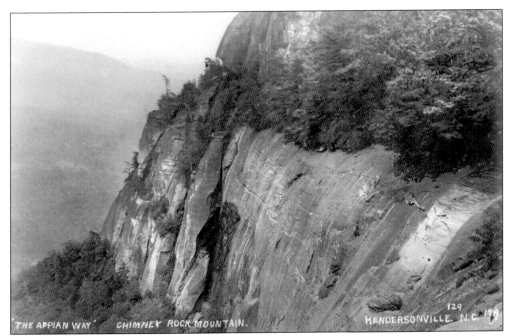

"THE APPIAN WAY" CHIMNEY ROCK MOUNTAIN. HENDERSONVILLE, N.C.

APPIAN WAY, C. 1900. In addition to the stairway to the monolith, J. B. Freeman's chief contribution to the park was a narrow trail from the base of the monolith along the cliff of Chimney Rock Mountain to Hickory Nut Falls, which he named the Appian Way. To create the trail, rock had to be blasted away with dynamite. Freeman probably chose the name because of an interest in Roman history.

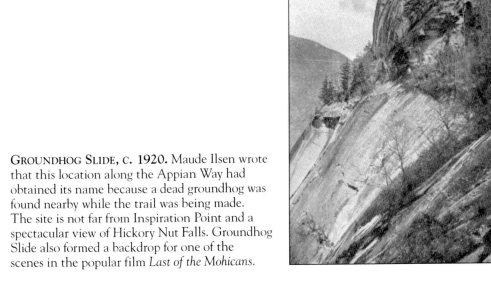

GROUNDHOG SLIDE, C. 1920. Maude Ilsen wrote that this location along the Appian Way had obtained its name because a dead groundhog was found nearby while the trail was being made. The site is not far from Inspiration Point and a spectacular view of Hickory Nut Falls. Groundhog Slide also formed a backdrop for one of the scenes in the popular film *Last of the Mohicans.*

41

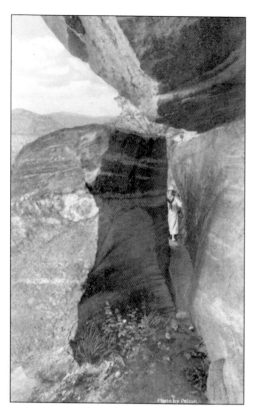

FAT MAN'S MISERY, C. 1920. The cliff trail is very narrow in some places, and at this point, about halfway between Chimney Rock and Hickory Nut Falls, blasting was necessary to create even a slight opening. Many years ago, the name "Fat Man's Misery" was replaced by "Wildcat Trap," perhaps to avoid offending obese visitors.

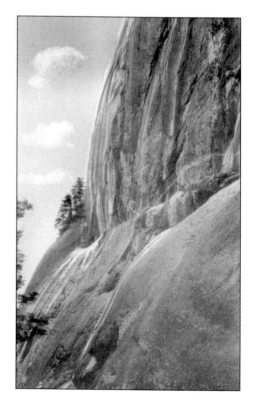

EAGLE'S NEST, C. 1920. This spot on the Appian Way takes its name from the fact that Freeman and his workmen discovered an eagle's nest here containing two young birds. The movie *A Breed Apart* (1984), some of which was filmed here, took as its plot efforts to save a nest of endangered eagles.

CHIMNEY ROCK MONOLITH, C. 1915.
This image illustrates well the way
Chimney Rock seems to grow out
of the mountainside, much like a
chimney pipe on the side of a building.
Its contours can present interesting
challenges to rock climbers. Since
at least 1940, these daredevils have
occasionally come to the park to scale
the monolith and nearby cliffs.

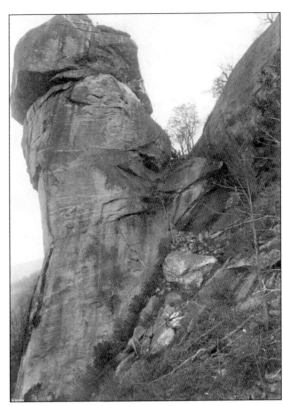

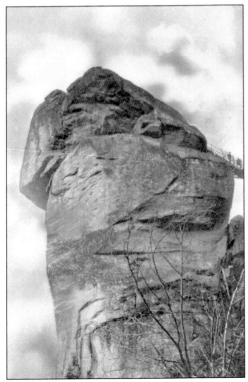

CHIMNEY ROCK MONOLITH, C. 1902.
Taken from an unusual angle, this
photograph was included in a Southern
Railway Company tour guide to Western
North Carolina. About this time, there
was considerable speculation about the
possibility of a railroad spur or interurban
line through the gorge. Consequently, the
Chimney Rock section saw a brief speculative
land boom around 1902 and 1903.

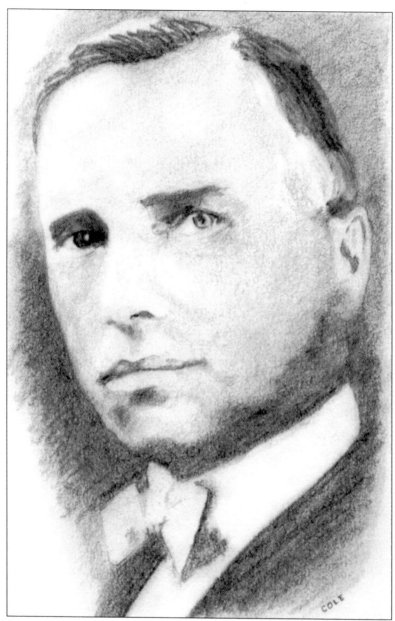

LUCIUS B. MORSE. The section's early-20th-century land boom led this man, Dr. Lucius Boardman Morse (1871–1946), along with his twin brothers Hiram and Asahel, to purchase Chimney Rock Park from Freeman in 1902. The rail line never came, so it took the arrival of the automobile and road improvements to spur the Morses on to dramatic improvements in the park. Born in Warrensburg, Illinois, the son of a farmer named Lemuel R. Morse, Dr. Morse resided in Hendersonville for many years. He graduated from Chicago Medical College in 1897 and practiced at Cook County Hospital in Chicago and in St. Louis before venturing to Western North Carolina. About 1901, he came to Asheville and was for many years associated there in practice with Dr. Westray Battle. His work was occasionally cited in early-1900s medical journals. Morse joined the successful push for better highways in the early teens and reached the pinnacle of his success between 1915 and 1927 with the development of the park and Lake Lure. (Drawing by author.)

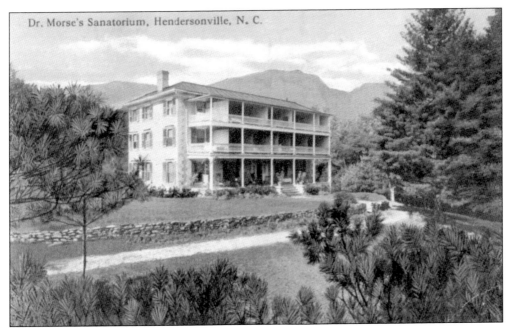

Dr. Morse's Sanatorium, Hendersonville, N. C.

DR. MORSE'S SANATORIUM, C. 1910. After acquiring Chimney Rock Park, Dr. Morse spent some years lobbying for a railroad, especially with the Seaboard Airline. But by 1908, he had given up. He practiced medicine briefly in Chimney Rock and then in Hendersonville, where he operated this facility for tubercular patients. Morse himself was afflicted with the disease.

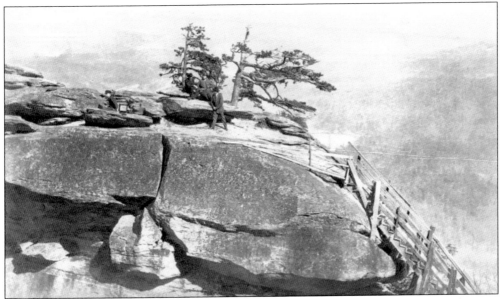

CHIMNEY ROCK MONOLITH, C. 1912. Note the device next to the gentleman who is seated among the boulders in this photograph, probably by A. F. Baker. It may well be a movie camera. During the second decade of the 20th century, several different movie companies came to the gorge to make films, usually crowding into the accommodations of the Esmeralda Inn.

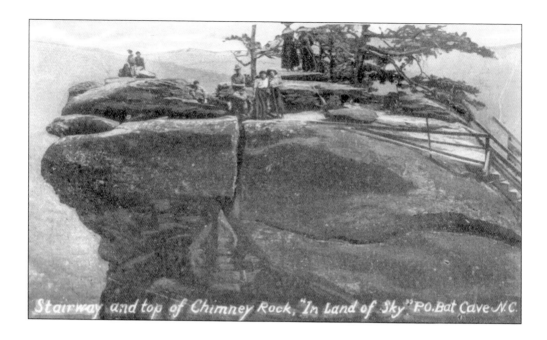

Stairway and top of Chimney Rock, "In Land of Sky" P.O.Bat Cave N.C.

CHIMNEY ROCK, C. 1910. The protective railing around the edge of the monolith is absent in these images. Though counterintuitive, this *does not* mean they predate the early Baker photograph of Chimney Rock (taken about 1890). During the first decade or so after the Morse brothers purchased it from Freeman, Chimney Rock Park was allowed to fall into disrepair. Quincy Sharpe Mills, a Statesville native and University of North Carolina at Chapel Hill student when he visited in 1907, wrote of the "rickety . . . trembling stairway" to the top of Chimney Rock and "the wooden railing about the edge . . . [of which] not so much as a splinter remained."

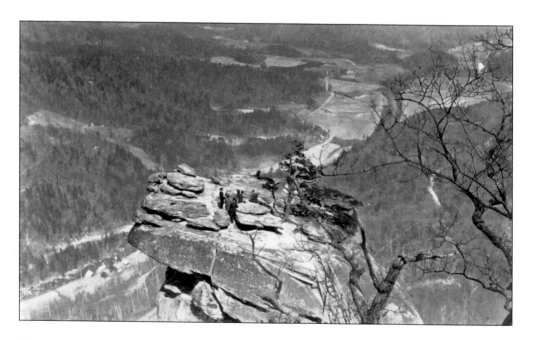

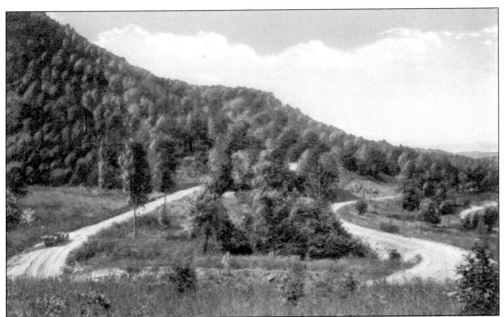

HICKORY NUT GAP ROAD, C. 1920. In 1912, it could take one and a half hours of contention with mud, holes, rocks, and ruts to drive from Rutherfordton to the Mountain View Inn, located across from Chimney Rock Mountain (about 20 miles). The Hendersonville road between Bat Cave and Edneyville was even rougher, and parts of the Hickory Nut Gap Road between Bat Cave and Asheville were literally impassable.

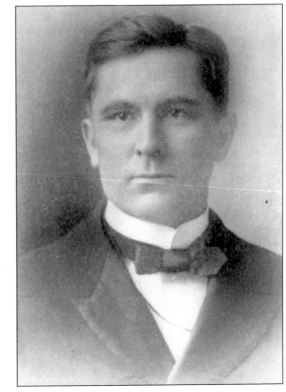

LOCKE CRAIG, C. 1915. North Carolina elected a new governor, longtime Asheville resident Locke Craig (1860–1925) in 1912. In his inaugural address, Craig said, "No community can hope for progress without the good road. We cannot have the benefits of modern civilization without it." Craig's Good Roads Movement had begun, and in early 1913, he approved convict labor for the Hickory Nut Gap Road.

HIGHWAY AND CHIMNEY ROCK, C. 1925. Seeing the potential better roads held for tourist development, Dr. Morse became, according to a Hendersonville newspaper, a veritable "good roads crank." At a Good Roads meeting in Edneyville in 1913, Morse told an audience of taxpayers debating the issuance of road bonds, "Yankees will not come here to stay without good roads and steam-heated hotels." The movement for better roads was gradually building momentum; before long, it became the region's most celebrated cause. One of the many forgotten figures in the movement was a Jewish politician from Rutherfordton named Sol Gallert. Echoing Morse, when the Charlotte to Asheville Highway was finally finished, Gallert said, "I look to see the time very soon when these hills will be the playground of America, the road lined with homes of summer visitors." Ironically, Gallert died in 1924, probably of a heart attack, trying to free an automobile stuck in a mud hole.

49

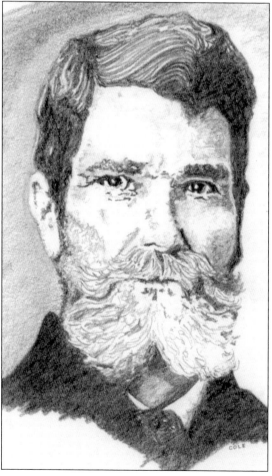

ROAD CONSTRUCTION, C. 1915, AND JOHN T. PATRICK. The state's contribution of convict labor to the roadwork along the Hickory Nut Gap Road was augmented by voluntary efforts of local citizens. John T. Patrick (1852–1918), a large landowner in the Chimney Rock section who was known as the Father of Southern Pines, originated the idea of Good Roads Days, in which volunteers worked on area roads during the summer of 1913. The work was divided into four sections of five miles each, and literally hundreds of volunteers pitched in for up to two days. On the last day of the work, reported the *Asheville Gazette*, a great barbecue was given with "the able assistance of the good ladies of the section." Governor Craig copied the idea with his own statewide Good Roads Days that November. (Drawing by author.)

CHARLOTTE TO ASHEVILLE HIGHWAY, c. 1920. Each milestone in the highway's construction was eagerly followed by the press and public. In August 1914, Rutherford County organized a festival to celebrate the near completion of the highway; by this time, it was finished save for the most difficult part: the Hickory Nut Gap Road between Bat Cave and Asheville, which was being worked by convict chain gangs. The celebration, which began on Rutherfordton's courthouse square, included a procession of automobiles, a brass band, and as with the Good Road Days, a big barbecue. The proceeds from ticket sales were contributed to further the roadwork.

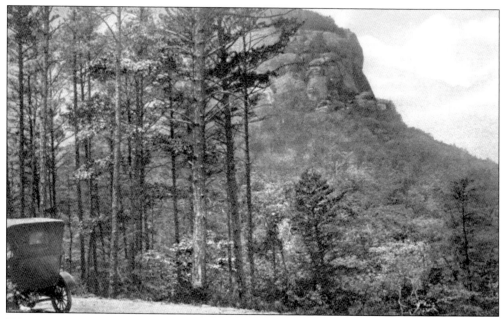

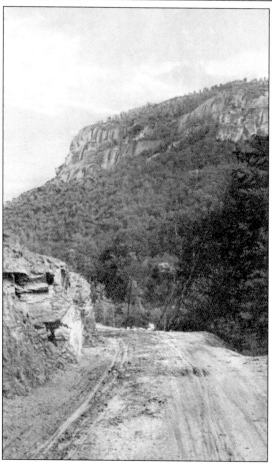

HIGHWAY AND CHIMNEY ROCK MOUNTAIN, C. 1920. Convicts continued work on the Hickory Nut Gap Road during 1914 and 1915. At last, the road was completed and dedicated by Governor Craig on November 6, 1915. The grand opening was held at Bear Wallow, not far from Bat Cave. "The presence of such a road with its beautiful scenery," the governor told an Asheville reporter the day before, "means that from now on hundreds of automobile parties will take advantage of it, and every year will find an increase in parties touring in machines to Asheville." The same would be true of Chimney Rock, creating a veritable explosion of summer visitors.

A YOUNG COUPLE, 1914. This image was taken in a photography parlor in Chimney Rock. Even before the Charlotte to Asheville Highway was completed, the area saw dramatic increases in tourist traffic. By June 1914, a Hendersonville paper reported that the inns were "rapidly filling with summer visitors and reservations . . . have excelled anything known in the history of the beautiful Hickory Nut Gap."

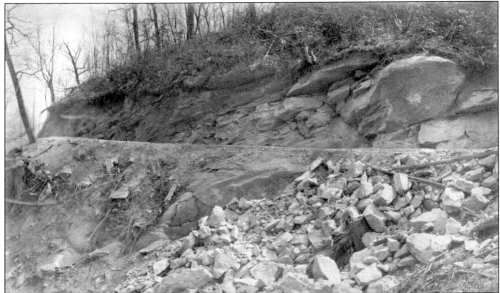

ROAD CONSTRUCTION, C. 1915. As the Hickory Nut Gap Road neared completion, Dr. Morse began drawing up plans for improvements to Chimney Rock Park. Chief among these was the replacement of the old foot trail to the monolith with a motor road to its base. Work on the road and parking lot was largely completed in time for the opening of the park in April 1916.

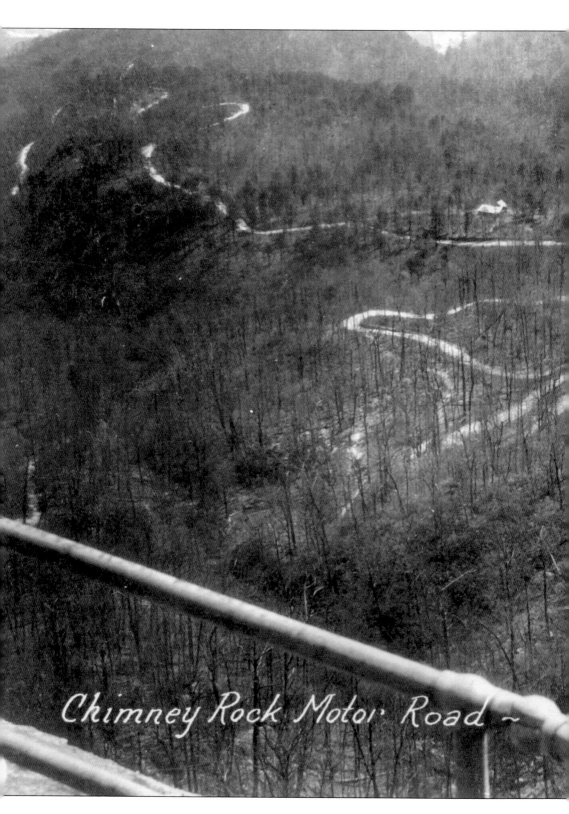

Chimney Rock Motor Road ~

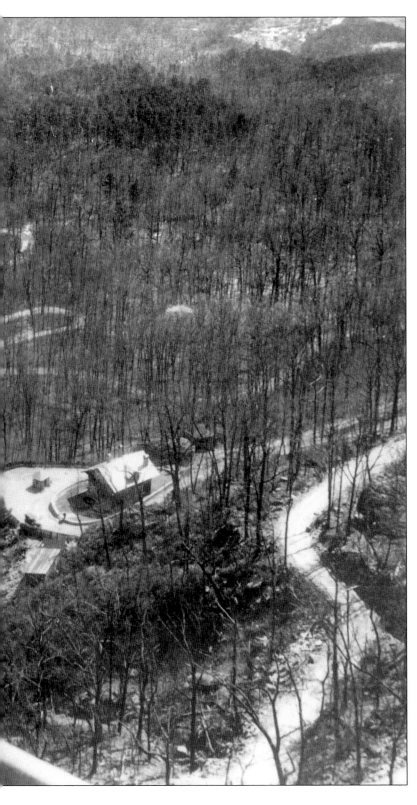

ABOVE THE MOTOR ROAD, C. 1920. This spectacular photograph, taken from the top of Chimney Rock, shows the recently completed road winding up the mountainside to the parking lot below the monolith; the Gatekeeper's Lodge, located partway up, is clearly seen below to the right. The road was 18 feet wide and 3 miles long with a grade of four to seven percent (two percent on the hairpin turns), and its construction was a formidable task for the time. Boulders as big as houses had to be blasted away. The first mile or so of the motor road rose gently, and the second mile followed the crest of what was called the Elysium Ridge. The third mile included numerous switchback reverses rising one upon another until at last the road reached the base of the monolith.

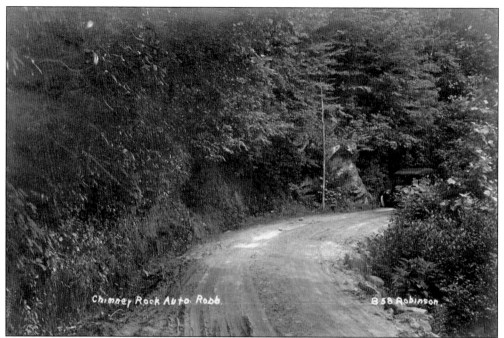

CHIMNEY ROCK MOTOR ROAD, C. 1920. Thousands had visited Chimney Rock when it was only accessible by foot. Many more would now come by car. But this brought with it other troubles. By June 1916, problems with litter in the park were so great that visitors had to be reminded "to collect and return to the shelter provided for this purpose all papers, bottles, and articles of food."

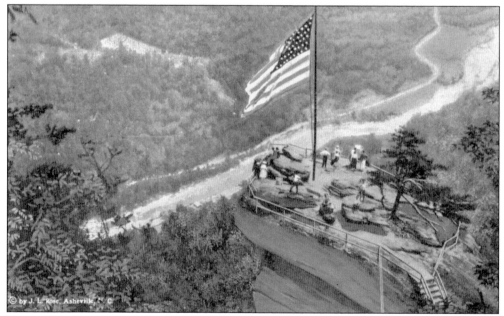

FLYING OLD GLORY, C. 1917–1918. On July 4, 1916, Chimney Rock celebrated the grand opening of the new motor road to the base of the monolith. J. B. Freeman was on hand, as were many other dignitaries. Here Old Glory flies above Chimney Rock in all its splendor, much as it must have that day. The above image coincides with America's entry into World War I.

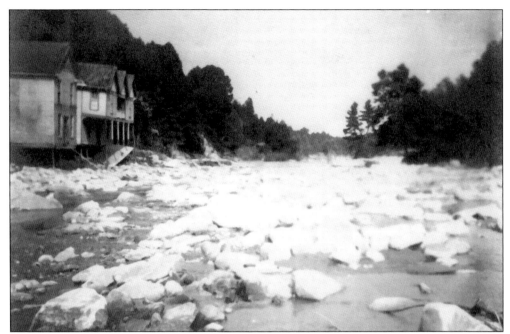

GREAT FLOOD OF 1916. Less than two weeks after the park's Fourth of July dedication, remnants of a pair of tropical storms turned the Rocky Broad River into a torrent that, as the *Asheville Citizen* put it, tossed "great boulders like bubbles" before it. Mountain slides of rocks and earth collapsed houses and buildings below. Virtually all the buildings in Bat Cave were swept away, and the new highway was ruined.

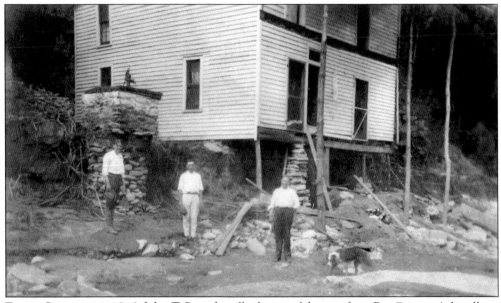

FLOOD SURVIVORS, 1916. John T. Patrick walked most of the way from Bat Cave to Asheville to convey the first news of the tragedy to the outside world. Relief efforts started in Rutherfordton and Asheville provided assistance to the more than 300 people trapped in the gorge. (North Carolina Collection, Wilson Library, University of North Carolina at Chapel Hill.)

AN OLD WALL, 1916. The destructive effects of floodwaters in the gorge are conveyed by this image of a well in the Chimney Rock Valley. Nine lives were lost in Bear Wallow, Bat Cave, and Chimney Rock, making this perhaps the worst flood in the history of Western North Carolina. Hickory Nut Gorge suffered destructive floods again in 1928 and 1996, though not on this scale.

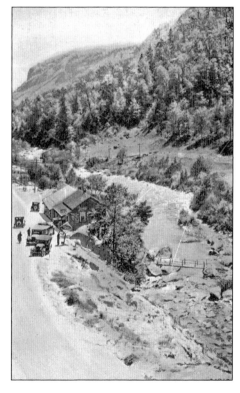

BAT CAVE VILLAGE, C. 1920. Bat Cave is pictured a few years after the great flood. By the summer of 1917, the road between Hendersonville and Bat Cave was again open, as was the Rutherfordton road, save for the few miles between Bat Cave and Chimney Rock. Though shaken, the hardy and stalwart people of the section rapidly recovered from the tragedy.

Three

THE HEYDAY OF THE PARK'S DEVELOPMENT
1916–1935

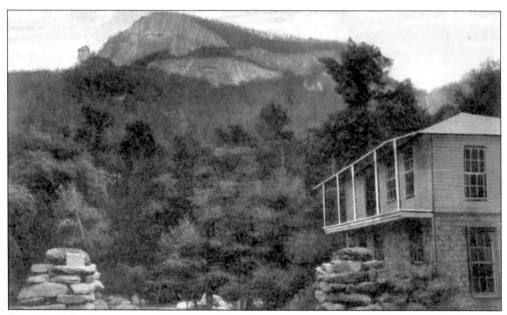

OLD PARK ENTRANCE, C. 1918. The old park entrance was located directly across from the Mountain View Inn. It survived the flood of 1916, though it was no longer used. But when the Chimney Rock Motor Road was completed a few weeks before the flood, visitors entered the park here; they then actually drove parallel to the river for 100 yards or so before crossing a bridge.

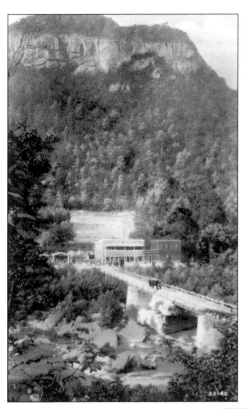

PARK ENTRANCE, FROM THE SOUTH, C. 1925. This postcard view looks from the south side of the Rocky Broad toward Round Top Mountain and Chimney Rock Village. When the park entrance was redesigned following the flood of 1916, visitors passed directly onto the bridge as they entered the park, just as they do today.

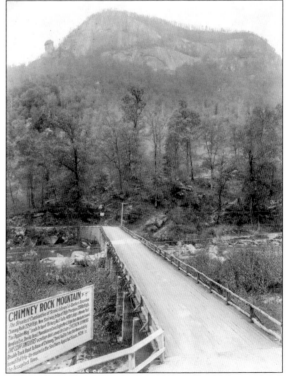

PARK ENTRANCE, FROM THE NORTH, C. 1925. This view from the north (or entrance) side takes in Chimney Rock Mountain. The sign to the left praises the park as "the Greatest Combination of Scenic Interest in Eastern America," lists all the many features of the park from spots on the Appian Way to chicken dinners, and notes the "Double Track Road to [the] base of [the] 'Chimney.'"

EAST SIDE OF ENTRANCE BRIDGE, C. 1925.
When the Chimney Rock Motor Road was completed in 1916, visitors actually had to cross two bridges and drive over an island before beginning up the mountain. As these spans were wiped out by the great flood, this new one must have been built shortly afterward, around 1917. Dr. Morse's new graded road to the base of Chimney Rock was damaged, but not severely.

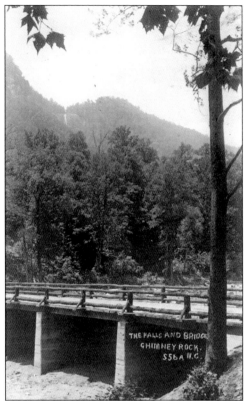

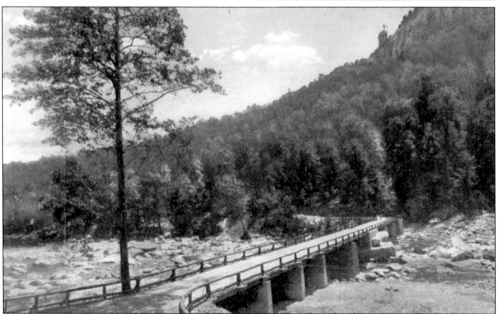

WEST SIDE OF ENTRANCE BRIDGE, C. 1925. This view, looking to the southwest, gives a good idea of the bridge's design: a simple beam structure with supporting piers and a wooden deck of rustic appearance. A portion of the deck seems to actually be supported by a giant boulder in the river, possibly one brought down by the great flood.

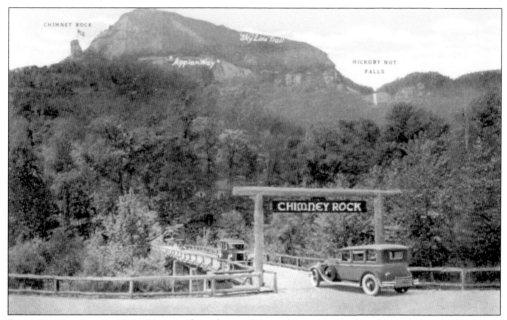

PARK ENTRANCE, C. 1930. Yet another phase of the entrance is displayed here. The sign hanging from above the bridge merely reads "Chimney Rock." Perhaps by this time Dr. Morse thought the park so well known that those two words alone were all the promotion necessary. The novelty of Chimney Rock had given way to familiarity.

PARK ENTRANCE, LATE 1930S. The entrance was further modified in 1934 and 1935 with the addition of a wall, company and ticket offices, restrooms, a reflecting pool, and a parking area. The gate was constructed using granite gneiss rocks from nearby—even the moss lichen growing on the rocks was left intact to lend a natural effect.

PARK BROCHURE, C. 1930. This item celebrates a half-million park visitors. Thanks to the coming of the automobile, highway improvements owing to the Good Roads Movement, and Dr. Morse's construction of a road to the base of the monolith, the number of visitors to the park increased dramatically after 1916. The park recorded 14,000 visitors during the 1917 season and 35,000 during 1919.

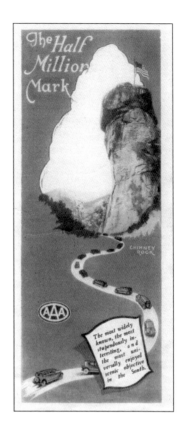

PARK BROCHURE, C. 1920. It is interesting that the park is described here as "the Lure." This brochure predates the development and construction of Lake Lure by several years. The lake's name is said to have been chosen by Dr. Morse's wife, Elizabeth Parkinson Morse, but perhaps the word *lure* was on the minds of the Morses before the idea of the lake was conceived.

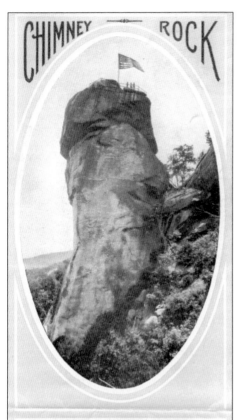

CHIMNEY ROCK

That Trip to "Chimney Rock"

How we've pictured it in our imagination! There's a keen thrill in it, too, like the abandon of childhood's days. All motor roads lead to Chimney Rock; but more particularly, it is on the Asheville-Charlotte Highway; Asheville, N. C., 26 miles; Hendersonville, N. C., 19 miles, both being Southern Railway points, and 20 miles from Rutherfordton—Seaboard Air Line Railway—in the very heart of the Blue Ridge Mountains.

On and on we motor up to the "Chimney's" very base. What a riot of scenery bursts upon the beholder! To dizzy heights do the giant cliffs rise sheer from the parking place. We almost shudder lest the great over-

PARK BROCHURE, C. 1922. Sometimes the park's promotional literature seemed to go too far. "How we've pictured it in our imagination!" reads this brochure. "There's a keen thrill in it, too, like the abandon of childhood's days. . . . On and on we motor up to the 'Chimney's' very base. What a riot of scenery bursts upon the beholder! To dizzy heights do the giant cliffs rise sheer from the parking lot."

APPROACH TO TOLL GATE, C. 1920. For many years, visitors paid admission to the park at this tollbooth, which was well up the Chimney Rock Motor Road next to the Gatekeeper's Lodge. The large boulder to the right gives some idea of the kind of obstructions that had to be overcome in building the road in 1916.

GATEKEEPER'S LODGE, C. 1920. This structure seems to have been constructed no later than 1918. As noted above, it was located about halfway up the mountain on the Chimney Rock Motor Road. A newspaper of the period was effusive in its praise for this building. "The Swiss chalet, or gatekeeper's lodge, is one of the beautifully developed portions of the grounds and is really a relief to the eye," reported the *French Broad Hustler* of Hendersonville, "for it is a thing of artistic beauty and affords a welcome change as a lonely piece of man's handiwork where that of the creator is flung out in such gorgeous profusion."

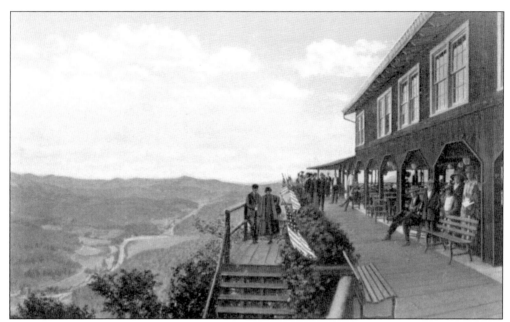

THE PAVILION, C. 1920. Constructed on the cliff just below Chimney Rock, this was the first public building that Dr. Morse added at the park. The Pavilion's grand opening was celebrated on July 1, 1918. The *Birmingham Ledger* soon proclaimed it "the most unique of restaurants." Visitors would be able to literally "dance in the air" with the spectacular Chimney Rock Valley below.

THE PAVILION AND CLIFFS ABOVE, C. 1920. A brochure for the 1919 season said of this rustic building and its surroundings, "Words convey only too poorly the enthusiastic delight and charm which everyone experiences in dining amid such inspiring surroundings. The verdure-clad panorama of mountain, cliff and plain that is spread before the diner is truly one of rare and exquisite beauty."

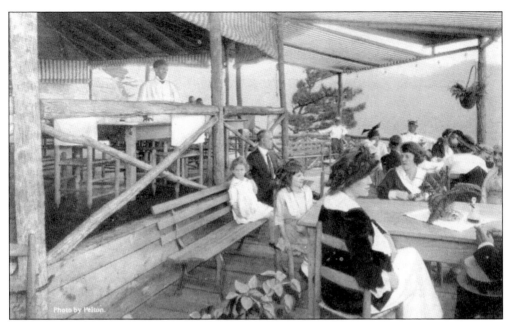

DINING AT THE PAVILION, C. 1920. Famished after their climb to the top of the monolith, the weary often dined on chicken dinners at the Pavilion. One of the justifications given for its construction while the country was at war was "the very great demand for meals." Dr. Morse assured visitors that "nothing has been overlooked to make both meals and service measure up to the scenery."

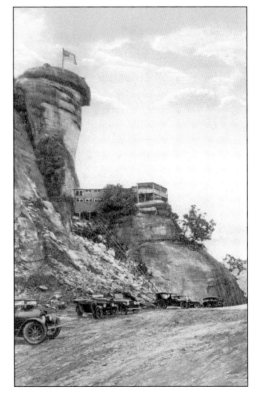

PAVILION AND MONOLITH, C. 1918. Judging from the rough appearance of the parking lot and the freshly blasted rocks just below Chimney Rock, this postcard view is probably contemporaneous with construction of the Pavilion. Note the absence of a tower on top of the restaurant; it seems to be only partly finished (compare to the following image).

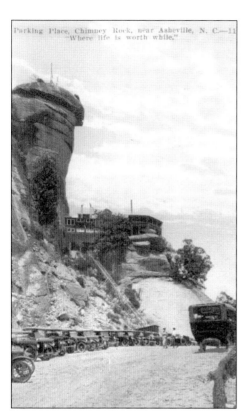

Parking Place, Chimney Rock, near Asheville, N. C.—11 "Where life is worth while."

PAVILION AND MONOLITH, C. 1920. A large automobile is parked to the right in this image. The vehicle is probably a 24-passenger Reo, which was used by the Hendersonville-Asheville Interurban Company when it experimented with service to Chimney Rock Park in May 1918, about the time the Pavilion opened.

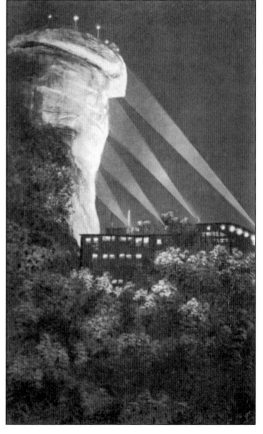

PAVILION SPOTLIGHTS, C. 1920. By late August 1919, Dr. Morse had placed spotlights on the Pavilion. Salesmanship and gimmickry has long been part of park advertising. J. B. Freeman briefly installed a waterfall on the monolith in 1899 and is even said to have driven a mule up the precarious stairway. In 1930, Morse introduced another gimmick: the Singing Stones.

PAVILION FROM THE TRAIL, C. 1920. The rear portion of the Pavilion served as the restaurant, while the open front section was designed for dancing and entertainment. The Pavilion Restaurant was supplanted by the Cliff Dweller's Restaurant (or Clubhouse) and then demolished, probably in the late 1920s; the front portion seems not to have been razed until the 1950s.

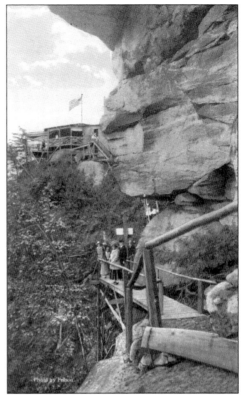

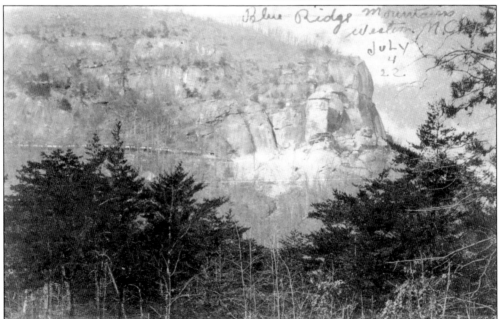

CLIFF DWELLER'S COTTAGES, C. 1920. The planning of 10 cottages for visitors (in this photograph, the row of buildings to the left of the monolith) began in the fall of 1919. But the 1920 season was nearly over before they were completed. The structures, designed by architect E. G. Stillwell, were furnished with hot water and showers, and each had a private balcony.

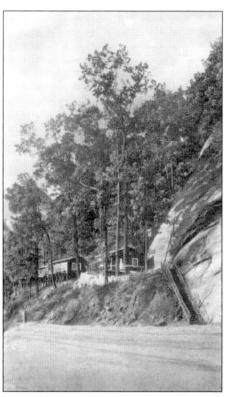

CLIFF DWELLER'S COTTAGES BEFORE RESTAURANT, C. 1920. This image affords a closer view of the cottages before the clubhouse was built. The plan of separate cottages was adopted "because of the impossibility of erecting a hotel all under one roof on the steep side of [the] mountain"; they were connected to the restaurant by a walkway. In the Cliff Dweller's later years, a cottage could be rented for $5 per night.

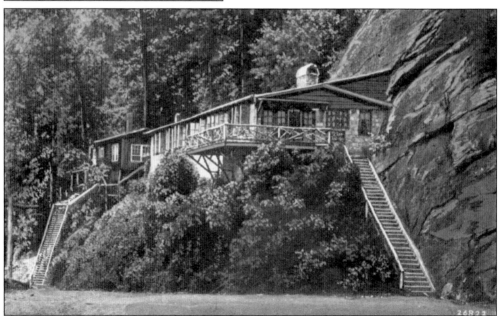

CLIFF DWELLER'S, C. 1930. The Cliff Dweller's Restaurant (or Clubhouse), shown in the foreground, was not added until the season of 1922. Morse hired Annie M. Gover as the first manager of the restaurant and cottages, assisted by Adelaide M. Jones. Gover had formerly worked at the Duncraggan Inn and other hotels in the Hendersonville area. At this time, the park itself was managed by John T. Arnett.

INTERIOR, CLIFF DWELLER'S, C. 1925. The cliff side of Chimney Rock Mountain actually formed the rear wall of the restaurant. The fireplace, built from native granite, was said to have been large enough to accommodate logs five feet in length. The Cliff Dweller's operated on the American Plan, providing meals and accommodations for one price.

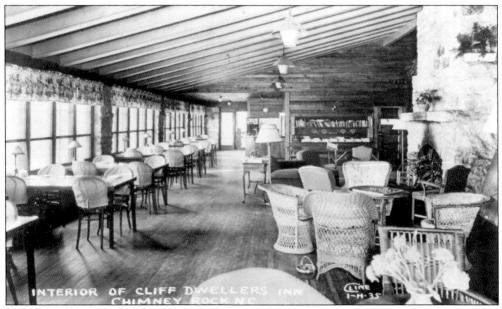

INTERIOR, CLIFF DWELLER'S, LATE 1930S. In addition to Annie Gover, other managers of the Cliff Dweller's included C. S. Fitzgerald, D. S. Thronson, Mr. and Mrs. Thomas B. Suiter, W. M. Stevenson, Mr. and Mrs. John H. Ward, H. V. Moon, and H. R. Nash. The restaurant and cottages were finally taken down to make way for the park elevator around 1947.

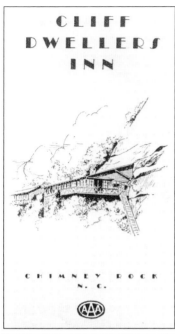

CLIFF DWELLER'S BROCHURE, C. 1940. "Each cottage has a large balcony where the guest may sit at peace and feast on the beautiful views and wide panorama, and search out the shoreline of Lake Lure far below," says the brochure. The cottages were far from "all disturbing sounds of traffic." Drinking water was piped in from refreshing mountain springs "high up among the cliffs and boulders."

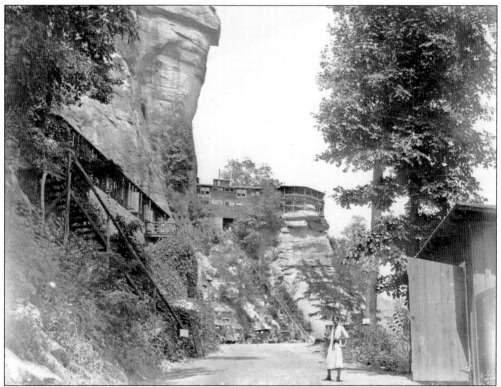

CLIFF DWELLER'S AND PAVILION, C. 1925. This snapshot by a tourist gives a good idea of Dr. Morse's plans for the park as they reached their maturity in the early 1920s: automobile access, dining, and lodging. After completion of the Cliff Dweller's Restaurant and Cottages, he turned his attentions to the development of Lake Lure.

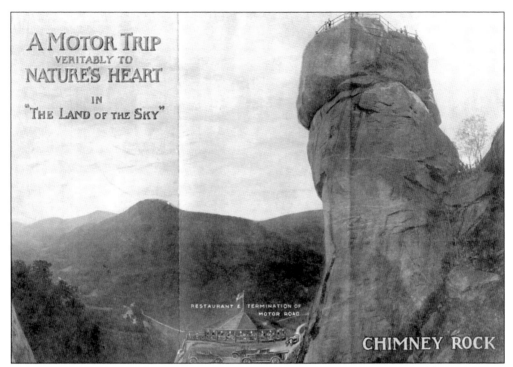

A MOTOR TRIP VERITABLY TO NATURE'S HEART

IN "THE LAND OF THE SKY"

RESTAURANT & TERMINATION OF MOTOR ROAD

CHIMNEY ROCK

PARK BROCHURE, C. 1918. Emphasis upon the slogan "A Motor Trip Veritably to Nature's Heart" and the terminal point of the Chimney Rock Motor Road highlight the park's only recent accessibility via automobile. The artist's rendering of the Pavilion is rather fanciful and does not include the restaurant, completed in the spring of that year.

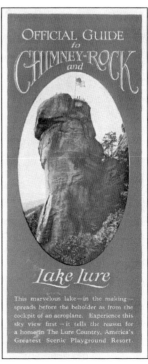

OFFICIAL GUIDE to CHIMNEY-ROCK and Lake Lure

This marvelous lake—in the making—spreads before the beholder as from the cockpit of an aeroplane. Experience this sky view first—it tells the reason for a home in The Lure Country, America's Greatest Scenic Playground Resort.

PARK BROCHURE, C. 1925. As well as providing information about the park, this brochure was used as a vehicle to advertise plans for Lake Lure, then under construction. "This marvelous lake—in the making—spreads before the beholder as from the cockpit of a aeroplane," it says. "Experience this sky view first—it tells the reason for a home in the Lure Country."

Chimney Rock

PARK BROCHURE, C. 1935. This brochure was issued not long after the new rock-walled entrance was completed. "At last," it proclaimed, "a more fitting entrance projects the wonders of Chimney Rock Mountain." Mention was made of the "inverted arch" design of the wall, accented by plantings of Italian cypresses; the new entrance also included a "Pictorium," which displayed views of the park.

CHIMNEY ROCK — PARKING PLACE — CLIFF DWELLERS INN
CHIMNEY ROCK, NORTH CAROLINA
3 HOURS FROM THE GREAT SMOKY MOUNTAINS NATIONAL PARK

GOV. KERR SCOTT, C. 1950. Scott's visit roughly coincided with completion of the park elevator in 1949, though a note on the back of this photograph suggests the purpose of his visit was to inaugurate the Lake Lure telephone exchange. The woman pictured is Dr. Morse's daughter Helen Elizabeth Richards Grieg. Her husband, Norman Grieg (1907–1979), managed the park for many years.

Four

ALONG THE TRAILS
OF THE PARK
1910–1950

FREEMAN'S APPIAN WAY, C. 1925. The trail is in places much narrower and steeper than this image would suggest. During the course of construction, wrote Maude Ilsen, Freeman's workmen often had to "let themselves down over the mountain by means of ropes" at the conclusion of their day.

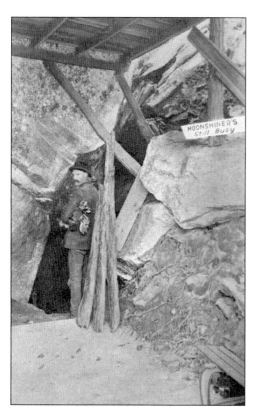

ENTRANCE, MOONSHINER'S CAVE, c. 1920. This is the first attraction visitors encounter on the way from the parking lot to the Needle's Eye and the walk up—unless, of course, they take the elevator. The cave is typical of fissure caves in the area, though smaller than the Bat Caves or the Rumbling Caves. It is located beneath Vista Rock, the rock pile upon which part of the Pavilion once stood.

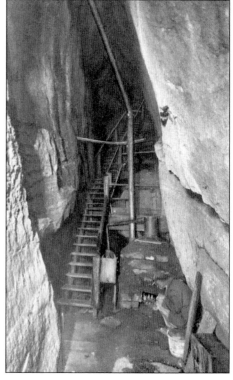

INTERIOR, MOONSHINER'S CAVE, c. 1930. The romantic stereotype associating the mountaineer with illicit distilling was perhaps an inevitable part of the park's promotion. "Moonshining" was indeed commonplace in this area, especially in the late 19th century. The temperature in the cave remains constant, so it can be a good place to cool off in the summer.

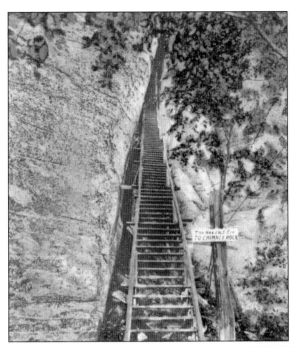

UP THE NEEDLE'S EYE, C. 1920.
Before the construction of the elevator (which was finished in 1949), visitors had to hike up a long flight of stairs to reach Chimney Rock. Their journey began through this narrow defile between Pulpit Rock on the left and the Rock Pile on the right.

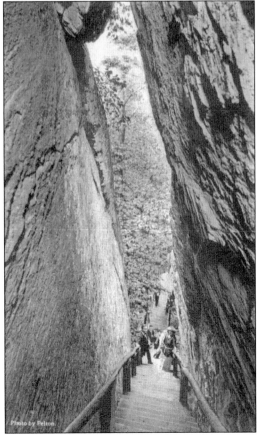

DOWN THE NEEDLE'S EYE, C. 1920.
The Needle's Eye was created by the same geologic process responsible for the formation of fissure caves in the area: the development of joints or cracks in the rock and differential erosion. It is 185 steps through the passage to the top, where boulders have accumulated to form the "eye of the needle."

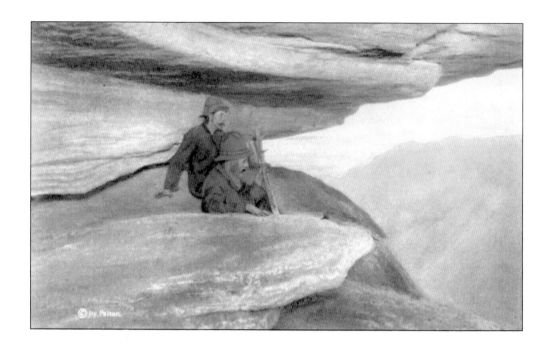

Moonshiner's Ledge, c. 1920, and the Grotto, c. 1930. Are these the same spot? The Grotto (below) is easy enough to identify, as it still carries the name; it is a ledge on the side of Pulpit Rock. It is also possible that this ledge was once called the Shelter, a spot identified in roughly this location in a 1940s brochure. At any rate, the nomenclature of the various attractions in the park has undergone change over the years. Fat Man's Misery, for example, was changed to Wildcat Trap. Long ago, even Hickory Nut Falls was at least by some referred to as Appalachian Falls.

PULPIT ROCK, C. 1925. This pile of rocks, nearly as impressive as Chimney Rock itself, sits beyond the Needle's Eye on the way to the monolith. For the venturesome who still walk up to the monolith from the parking lot, this is a good place to rest for a bit before navigating the remaining stairs to the top.

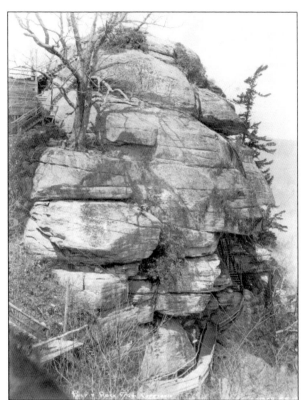

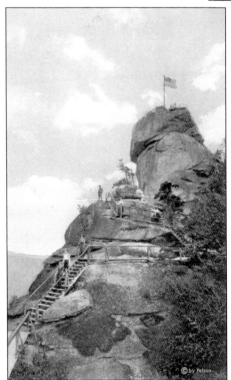

STAIRWAY OVER PULPIT ROCK, C. 1920. A local man named Guilford Nanney has been credited with much of the early work on the steps and stairways in the park. This photograph, as well as others of the park trails, was made by Herbert W. Pelton of Asheville, who took many fine photographs of the area from 1910 into the 1920s.

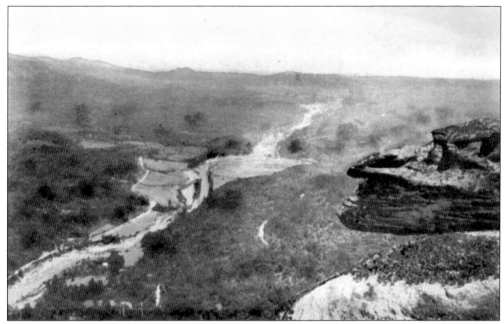

OLD INDIAN CHIEF, C. 1920. This curious feature, formed by erosion over many, many centuries, is encountered on the way up to Chimney Rock. The valley road and the rich farmlands adjacent to the Rocky Broad River are both well displayed in this image, which of course predates the construction of Lake Lure.

A MOMENT'S PAUSE, C. 1925. These men are probably resting atop Pulpit Rock. The fellow on the left seems to be doing fine, but the man on the right is clearly perspiring a little. Climbing to the top via the steps is not well suited to just anyone. The trek is not only strenuous, but vertiginous as well.

OLD STAIRWAY TO MONOLITH, C. 1910.
This photograph affords a fairly good view of the original stairway constructed by Watt Foster in 1890. It took courage to climb those old steps. Quincey Sharpe Mills wrote in 1907 that his friends "essayed the trembling stairway with a misgiving only too apparent." J. B. Ivey, who was there about 1893, thought of the stairway as no more than a "rude ladder."

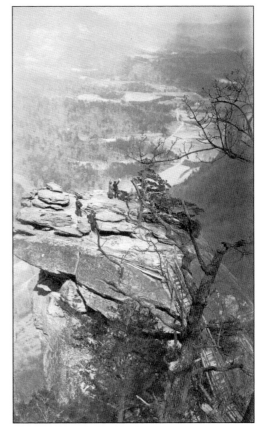

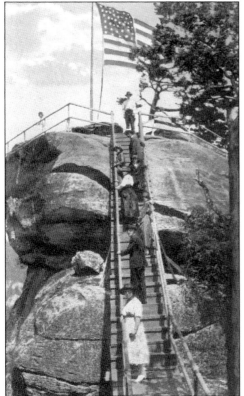

STAIRWAY TO CHIMNEY ROCK, C. 1920.
This is the second stairway. Presumably at the same time it was completed, new, protective metal railing was installed around the top of the monolith to replace the original wooden railing built by Watt Foster, which had long since rotted away. These improvements were likely made in 1916 and were certainly in place by the season of 1918.

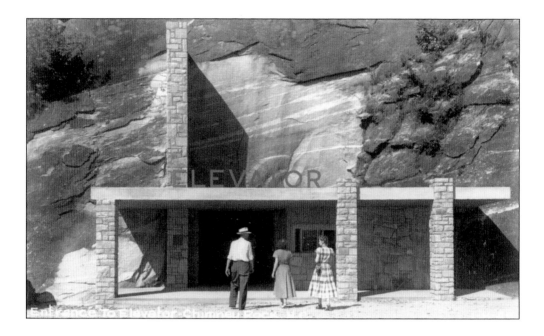

PARK ELEVATOR ENTRANCE AND TUNNEL TO ELEVATOR, C. 1950. For nearly 60 years, visitors have been able to avoid the maze of stairways through and over the Rock Pile and Pulpit Rock and ride up to Chimney Rock in just a few seconds. The elevator carries its passengers to the Sky Lounge, a restaurant and gift shop situated on top of the cliff just 200 feet back of and on the same level with the monolith. The shaft of the elevator rises 250 feet through solid rock; the tunnel to the elevator (below) is 190 feet long. Crews took 18 months to construct the elevator, which began service in May 1949.

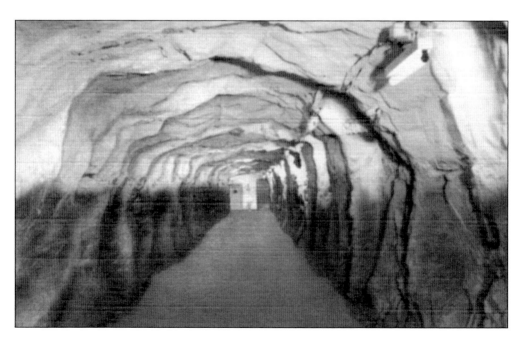

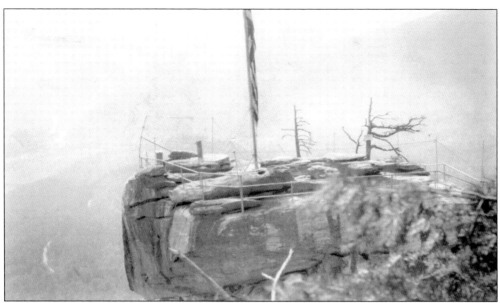

TOP OF CHIMNEY ROCK, c. 1925. Above is a snapshot taken by a tourist of the top of the monolith on a bright but rather hazy, windless day—typical of the section during the hot, humid summer months. Note the dwarf pines, both of which appear to be dead; the trampling of hundreds of thousands of visitors gradually wore away the topsoil, and the trees could no longer be sustained. They were finally removed about 1930. The one on the right is posted with a danger sign, probably to discourage tourists from attempting to climb it. Below, in another snapshot, tourists take in the view. A podium is visible to the right rear of this group; the purpose of the wooden cabinet in the left foreground is unknown.

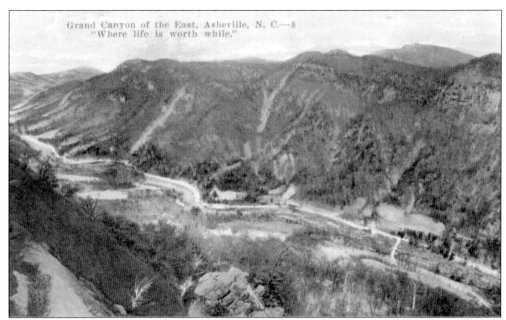

UP HICKORY NUT GORGE, C. 1920. This view takes us nearly straight down from the monolith into the valley below, then northwest up the gorge toward the village of Bat Cave. The vertical white line in the lower right is the park's entrance, where the bridge crosses the Rocky Broad River. A little to the west of this is the old entrance, and across from this point is the Mountain View Inn.

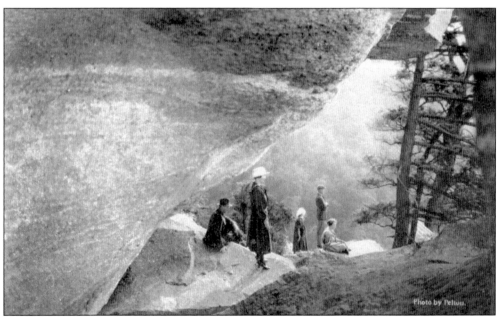

INSPIRATION POINT, C. 1920. Located on the Appian Way, this spot affords a fine view of Hickory Nut Falls. Scenes from the film *Last of the Mohicans* were filmed here in 1992. Hawkeye, played by Daniel Day-Lewis, and Cora, Madeleine Stowe's character, have a particularly memorable scene at this romantic site.

HICKORY NUT FALLS, C. 1915. Occasional dry weather can cause the falls to narrow to a comparatively small stream, as seen here. In the 19th century, traveler Charles Lanman described the stream of water responsible for the falls almost poetically as what seemed to him an "offspring of the clouds."

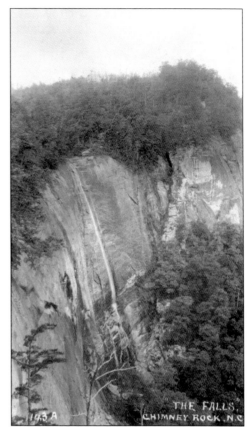

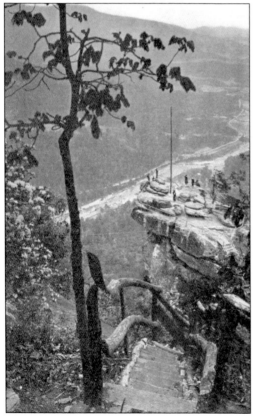

CHIMNEY ROCK AND VALLEY, C. 1920. This photograph was taken from the trail above the monolith. When the dam was completed and the lake filled during 1926 and 1927, the farmlands along the Rocky Broad in the Chimney Rock Valley disappeared forever. The waters of the lake both literally and figuratively symbolized a rebirth, as agriculture gradually gave way to tourism.

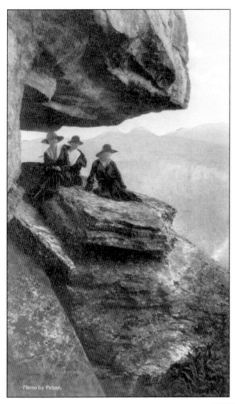

Photo by Pelton.

OPERA BOX, C. 1920 AND 1925. Many natural features in the park, such as the Opera Box, have been modified by the hand of man—a rock wall was added to this feature in the early 1920s, as can be seen in the image below. The natural box-like appearance of the Opera Box (see left) was initiated by layering or banding in the rocks. This caused them to break easily where the bands came in contact, thus forming the Opera Box. The same geological process is also responsible for the cracking and shifting of the top of Chimney Rock. The Opera Box is also an excellent vantage point for photographs, especially of the monolith. Over the last century, untold thousands of snapshots must have been taken by tourists from this location.

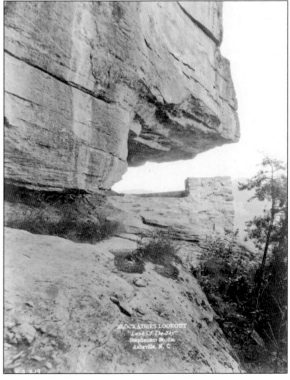

DEVIL'S HEAD, C. 1920. This strangely shaped boulder is located on a ledge just off the Skyline Trail and above Chimney Rock and the Opera Box. According to geologist Dr. James Matthews, the boulder broke "away from the cliff face along a crack [and] slid and rotated away from the cliff on the ledge. The face has been carved by years of exposure to the elements."

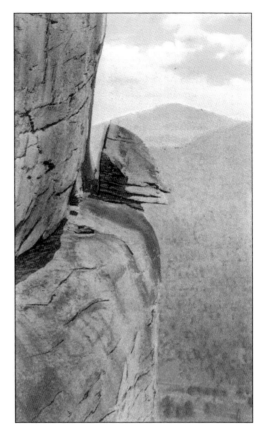

SKYLINE TRAIL, C. 1930. This trail ascends from Chimney Rock and courses over the top of Chimney Rock Mountain to Hickory Nut Falls. It thus runs parallel to and above J. B. Freeman's better-known Appian Way. It was probably constructed by Freeman, for a 1915 article mentions ascending by ladders to a trail above the "Wonderland Trail"— another name for the Appian Way— and then backtracking to the monolith.

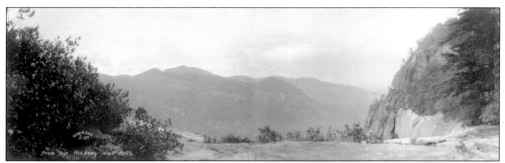

ABOVE HICKORY NUT FALLS, C. 1920. The mountain across the gorge is Round Top. To walk the Skyline Trail and back typically takes one and a half to two hours. But the tremendous views are, of course, well worth the visit. One should be cautious, though; over the years, several people have lost their lives near the falls.

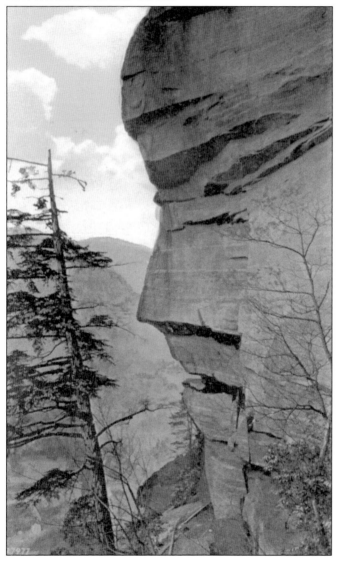

OLD KING TUT, C. 1925. Popular culture also has had its influence on park nomenclature. This feature along Freeman's old trail, the Appian Way, must have been named long after his time, no doubt inspired by Howard Carter's discovery of the tomb of King Tutankhamun in Egypt's Valley of the Kings in 1922.

Five

THE DEVELOPMENT
OF LAKE LURE
1923–1927

CHIMNEY ROCK VALLEY, C. 1920. With completion of the Cliff Dweller's Restaurant and Cottages, park development paused. Dr. Morse next turned his attentions to building a huge summer resort in the area. Central to this idea was the damming of the Rocky Broad River and the creation of a scenic, recreational lake. Soon water would cover the land in the foreground of this postcard.

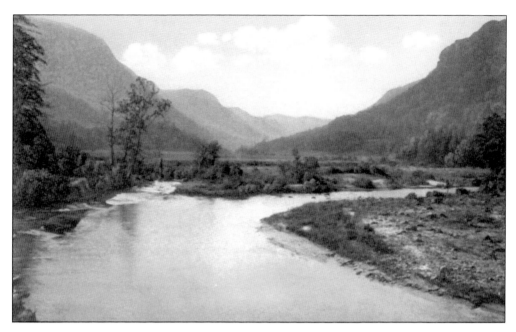

BEFORE LAKE LURE, C. 1920, AND COMPLETED LAKE, C. 1930. The first task toward realizing Dr. Morse's dream was to acquire land along the Rocky Broad River, seen above. By late 1923, approximately 8,000 acres in the valley below Chimney Rock had been purchased at a price of $134,000. Morse also recruited the help of business leaders in the region and applied for a certificate of incorporation, creating an entity called Chimney Rock Mountains, Inc. The company was capitalized at $4 million in 1924. According to Rutherford County historian Clarence Griffin, this was "the largest corporation ever granted a charter in North Carolina up to that time." Establishing its offices in the old Harris Tavern, Chimney Rock Mountains, Inc., would serve as the vehicle by which scenic Lake Lure was planned and executed.

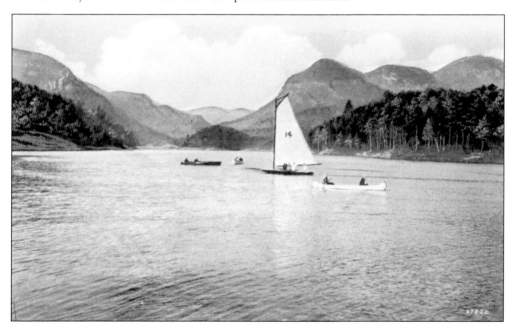

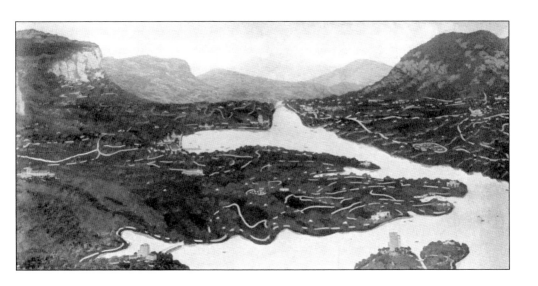

ARTISTS' CONCEPTIONS OF THE LAKE, C. 1925. Dr. Morse foresaw a lake with many hundreds or even thousands of summer homes—a vision that was not completely realized until after his death. By the 1920s, social and economic developments were giving rise to an affluent urban middle class in the South. Summer vacation homes were no longer simply for the rich; more and more people of moderate income desired and could now afford a second home in the mountains or on the beach. During this decade, Florida experienced a veritable land-speculation mania. Though North Carolina would not undergo development on the scale of the Sunshine State, the booming 1920s nonetheless help explain the creation of Lake Lure.

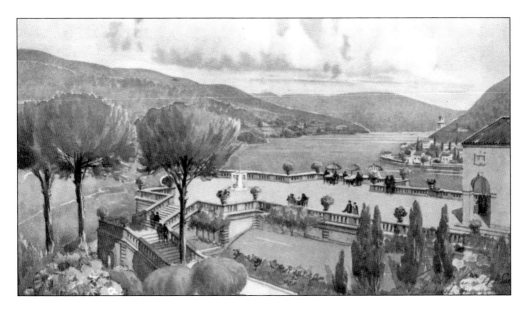

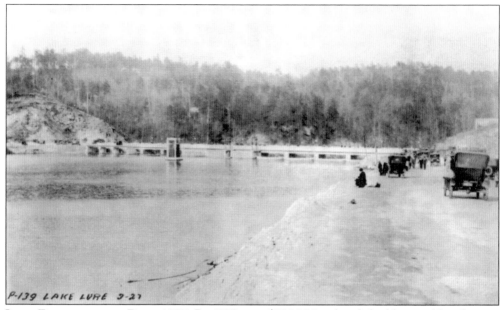

LAKE FILLING BEHIND DAM, 1927. By 1925, over $500,000 in bonds had been sold to finance the dam, and construction had begun early that same year. The damming of the Rocky Broad would create a lake of over 1,500 acres with about 27 miles of shoreline. Impoundment began on September 20, 1926, and was completed early the following year. (North Carolina Division of Archives and History.)

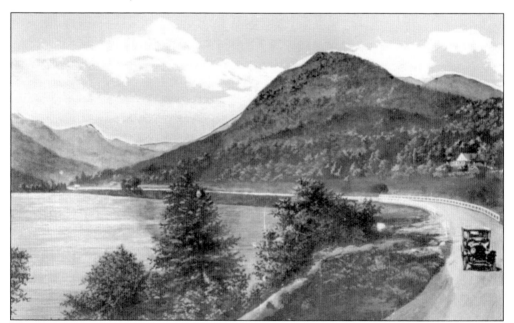

HIGHWAY, LAKE LURE, C. 1925. Lake Lure would cover part of the Charlotte to Asheville Highway, so a substitute road had to be built. This interesting image, made after the closing of the dam in 1926, shows the old highway skirting past Round Top on the northern edge of the lake. When completed in 1927, Highway 20 (now U.S. 74) was the first paved highway across North Carolina.

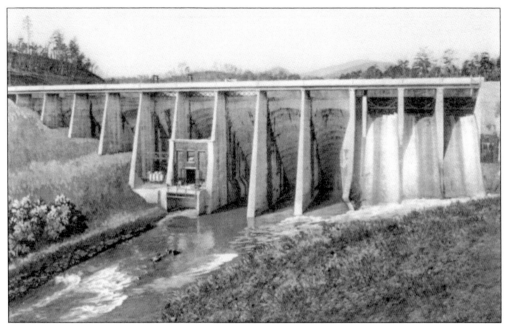

LAKE LURE DAM, C. 1930, AND LAKE LURE, C. 1927. In addition to creating a beautiful lake, the dam (above) would also generate power. To that end, Chimney Rock Mountains, Inc., created a subsidiary called the Carolina Mountain Power Company. Sale of power began in 1928, soon after the dam project was completed. The original hydroelectric plant, now owned by the Town of Lake Lure, is still in use, and the electricity it produces is sold to Duke Power. Contrary to popular belief, the dam does not furnish power for Lake Lure—not enough is made to meet the needs of the town. Generating power has been secondary to the primary purpose of maintaining water levels of the lake for recreation. The striking perspective below of Lake Lure during construction is now familiar to any Chimney Rock Park visitor.

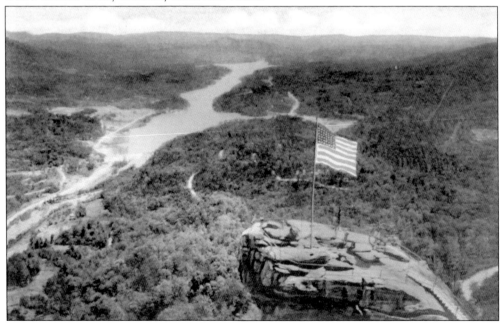

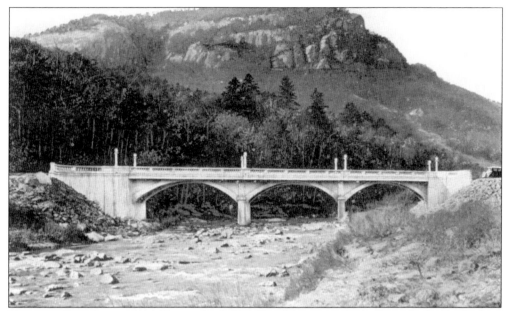

HIGHWAY BRIDGE, C. 1925. Five and a half miles of new concrete highway had to be built to accommodate the lake, and three bridges, described as "highly ornamental" by the *Forest City Courier*, were constructed for the rerouted highway. This one, crossing the Rocky Broad near what would become the west end of the lake, is 175 feet long. The other bridges—over Cane Creek and Pool Creek—are 110 and 32 feet in length, respectively.

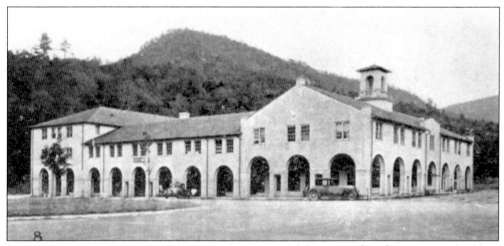

LAKE LURE ADMINISTRATION BUILDING, C. 1929. Work began on the administration building for the new town of Lake Lure, located just a short distance from the Lake Lure Inn, in June 1926. The day the cornerstone was laid was taken as an opportunity to celebrate Dr. Morse's vision and achievement. An army general spoke and a military band played. Over 3,500 people attended.

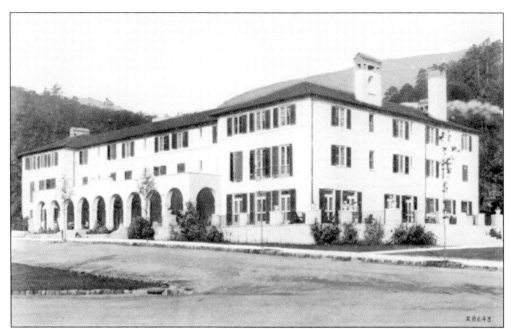

LAKE LURE INN, C. 1930. Chimney Rock Mountains, Inc., planned to construct at least two hotels, but ultimately only the Lake Lure Inn was completed before the financial panic of 1929 forced the dissolution of the company. Work on the 56-room hotel, with its high arches and stucco of Northern Italian design, began in early 1926 and was finished later that year. In the late 1930s, the Lake Lure Inn was run by Mr. and Mrs. Stanley Gresley. Advertisements highlighted the French windows in the dining room, the veranda, and the views of Rumbling Bald and the lake in the afterglow of the evening sun or at moonrise.

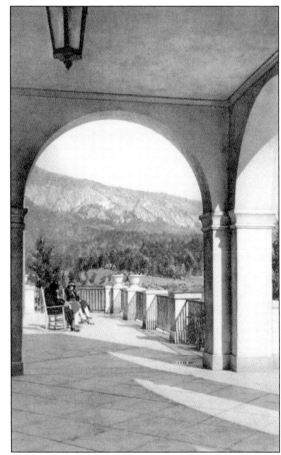

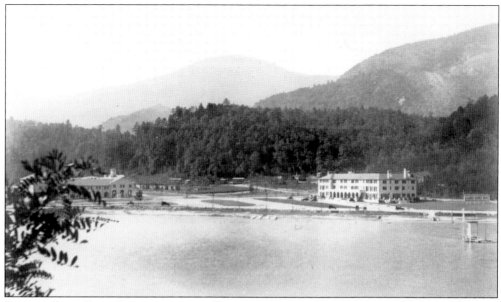

INN AND LAKE LURE ADMINISTRATION BUILDING, C. 1930. Construction of these buildings, as well as the entire development of Lake Lure, was planned and directed by landscape architect E. S. Draper of Charlotte, North Carolina. The program included additional golf courses, sports facilities, a clubhouse, and numerous subdivisions, all of which were stymied by the Great Depression.

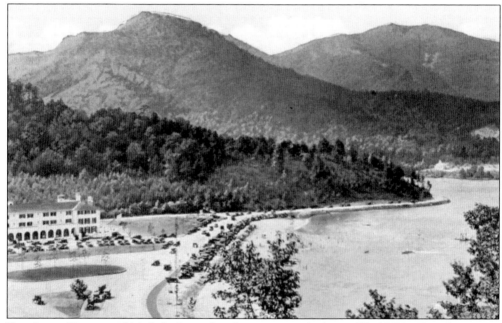

BIRD'S-EYE VIEW, C. 1930. Lake Lure played a patriotic role during World War II. In June 1943, the U.S. Army leased the Lake Lure Inn and employed it as a rest center for pilots and enlisted men returning from service overseas. Approximately 5,000 men passed through the Lake Lure Rest Camp over about two and a half years. Coeds by the busload came to dance and entertain them.

LAKE LURE INN BROCHURE, C. 1940. The Lake Lure Inn has had many owners over the years. When the popular film *Dirty Dancing* came to the area in 1986, the movie company stayed at the hotel and shot most of the scenes on then-owner John Mojjis's property. A couple of years later, Mojjis declared bankruptcy. The building was extensively renovated in the 1980s and 1990s.

LAKE LURE GOLF COURSE, C. 1930. Five golf courses were actually planned by Chimney Rock Mountains, Inc., but only this one—designed by the Florida firm of Stiles and Van Kleet—was completed. Work began in early 1926. Many claimed that it would rival some of the finest courses in the country.

97

DR. MORSE IN AUTOMOBILE, C. 1925. The words "Lake Lure" are written across the grill of this car parked along the Charlotte to Asheville Highway, suggesting it was a promotional vehicle owned by Chimney Rock Mountains, Inc. Tragically, in 1928, a vehicle driven by Dr. Morse struck and killed Albert Morgan, a well-known local man. The death was ruled accidental.

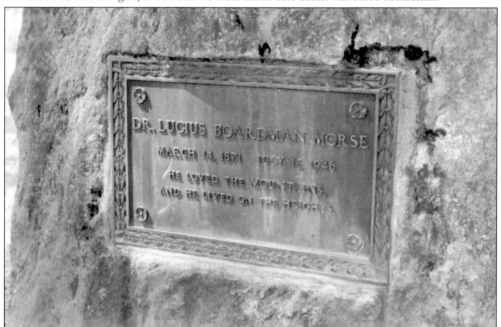

TOMBSTONE OF LUCIUS B. MORSE. Dr. Morse retired in 1936, turning management of Chimney Rock Park over to his son-in-law Norman Grieg. In poor health during his later years, he passed away at an Asheville sanatorium on July 13, 1946. Appropriately, he lies buried at Chimney Rock Baptist Church in the valley that he so loved and to which he gave so much.

Six

INNS AND CAMPS
1800–1950

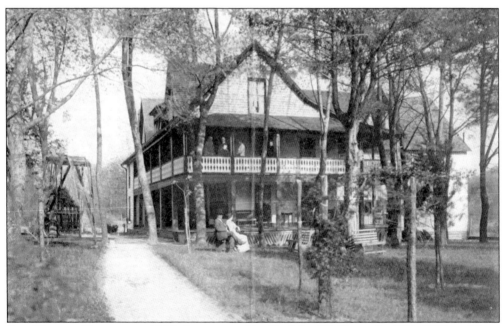

OLD HARRIS TAVERN, C. 1900. Long owned by Dr. John W. Harris (c. 1791–1859) and later by Judge George W. Logan (1815–1889), a prominent politician in Rutherford County during Reconstruction, this tavern was for many years the area's primary inn. Built about 1800, it served as a stagecoach stop on the Hickory Nut Gap Turnpike. It was also called Pine Gables. (Duke University Library Special Collections.)

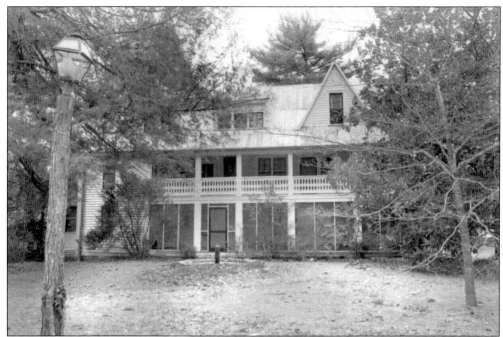

OLD HARRIS TAVERN, C. 1987. When Lake Lure was built, the highway was rerouted and bypassed the Harris place. One of its more interesting owners during these later years was a local man named Jim Washburn. In 1952, Washburn published a hilariously funny memoir of his youth growing up in Rutherford County called *Jim the Boy*. Writer Tony Earley recently borrowed this title for his popular novel.

GRAVE OF "COL." THOMAS TURNER. A native Scotsman, Turner (1839–1910) rose to the rank of sergeant (honorary colonel) with the 1st New York Mounted Rifles during the Civil War and then returned to Yonkers, New York, where he worked as a cabinetmaker. About the time J. B. Freeman opened Chimney Rock Park, he convinced Turner to come to Bat Cave and build the Esmeralda Inn. Turner is buried at Chimney Rock Baptist Church.

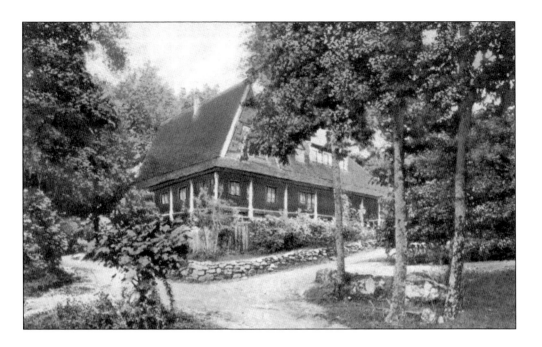

ESMERALDA INN, C. 1910. The original Esmeralda Inn, built in 1891 by Col. Thomas Turner on a Speculation Land Company tract between Chimney Rock and Bat Cave, could hold about 45 guests. It was named after the heroine of Frances Hodgson Burnett's then-popular stage drama by the same name. During the second decade of the 20th century, it attracted notoriety as a haven for silent film acting companies from New York and elsewhere that frequented the gorge. From the period of its inception until J. M. Flack's enlargement of the Mountain View Inn in 1916, the Esmeralda was the leading hotel in the gorge. The original structure burned in February 1917.

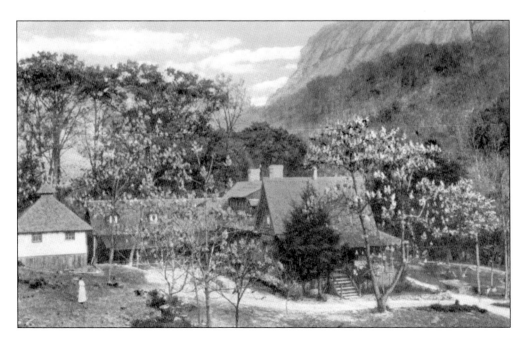

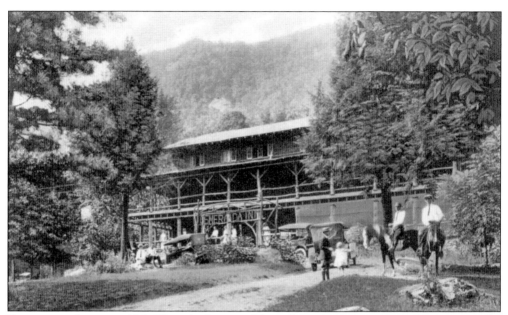

ESMERALDA INN, C. 1925. The rebuilt inn celebrated its grand opening on July 1, 1917. The new three-story Esmeralda could accommodate about 40 guests and continued to attract movie stars. A grand dinner was served to celebrate the reopening, attended by J. B. Freeman and John T. Patrick, who extolled the virtues of the late Colonel Turner and the gorge's promise as a tourist mecca.

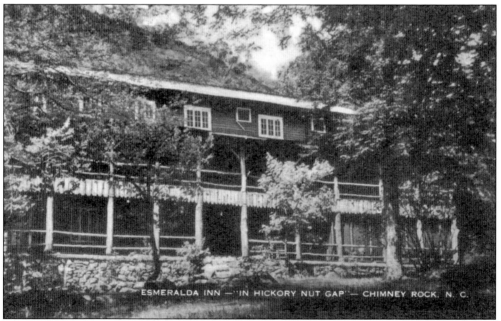

ESMERALDA INN, C. 1940. Long one of the chief landmarks of the section, the Esmeralda was known far and wide for its hospitality, ambience, and grand scenery. The main columns of the interior were giant tree trunks, and three stairways led up from a large room on the first floor to the guests' quarters and mezzanine floors. A large fountain was situated in the center of the dining room.

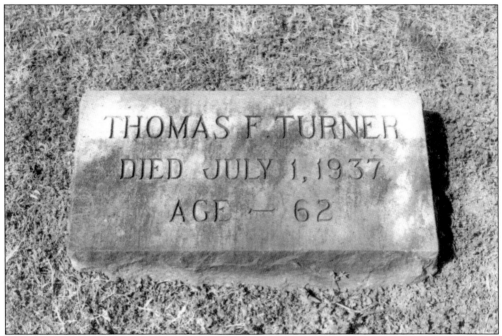

GRAVE OF THOMAS F. TURNER. Turner's son Thomas F. Turner (c. 1875–1937), who also bore the honorary title of colonel, operated the Esmeralda Inn for many years after his father's death. The younger Turner was known for being very active in promoting Chimney Rock and Bat Cave. He is buried next to his father at Chimney Rock Baptist Church.

ESMERALDA INN

CHIMNEY ROCK, N. C.

W. EDGAR FLACK, Proprietor

Season of 1937	Daily	Weekly
Single with private bath _____	$4.00	$25.00
Double with private bath (twin beds)	3.75 Each	22.50 Each
Double with private bath (one bed)	3.50 Each	21.00 Each

AMERICAN PLAN

Extra Meals

Breakfast 50c	Dinner 75c	Supper 75c

BUSINESS CARD, C. 1937. Thomas F. Turner was succeeded as owner of the Esmeralda by J. M. Flack's son W. Edgar Flack (1877–1967), who purchased and renovated the inn from cellar to garret following Turner's death in 1937. His business card describes the cost of rooms and meals. This landmark was again destroyed by fire in 1997, but was rebuilt a few years later.

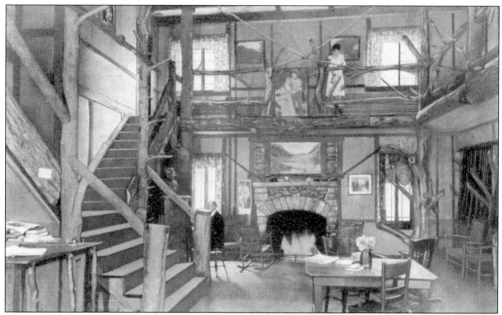

LOBBY, ESMERALDA INN, C. 1920. If only those old walls could have talked, what stories they might have told! Famous 19th-century atheist and lecturer Robert G. Ingersoll is said to have once praised the elder Turner's whiskey "as the finest to ever drive a skeleton from the feast or paint landscapes in the brain of man." Acting troupes of the early 1900s must have done a little drinking too.

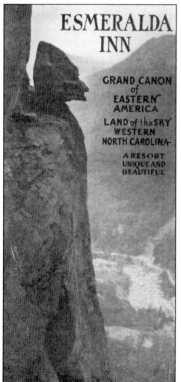

ESMERALDA INN BROCHURE, C. 1940. Perhaps all the deviltry at the inn had something to do with the choice of Devil's Head for the cover of this brochure. In 1914, Ned Finley, probably the most frequent of the Esmeralda's actor-guests, suffered a concussion while filming a canoe scene on the Rocky Broad. A few days later, the actor was found delirious, wandering the streets of New York City.

HONEYMOON TOWER, C. 1915. Many of the Esmeralda's movie star guests crowded into this quaint structure, now long gone. Actors who stayed here during the second decade of the 20th century included, in addition to Finley, Ethel Clayton, Barry O'Neil, Ada Gifford, and Edith Storey. They made such films as *The Return of O'Garry*, *The Caveman*, *Mountain Law*, and *The Raiders of Sunset Gap*.

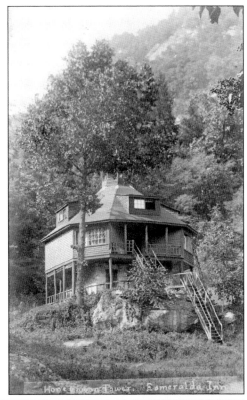

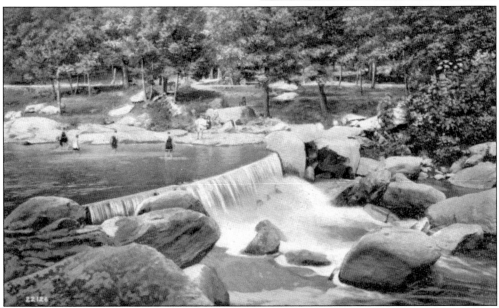

SWIMMING, ESMERALDA INN, C. 1920. Guests at the Esmeralda often enjoyed swimming, horse and mule riding, hunting, and fishing. The *French Broad Hustler* recorded that "typical mountain characters" would pose for photographs, and visitors were shown the so-called Phantom Arch, a mountainside optical illusion nearby, where a bridge appeared to swing between "immense masses of castle-like rock."

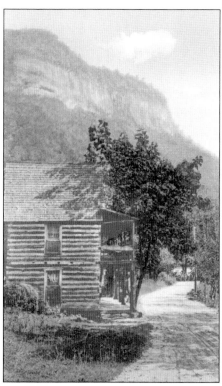

FREEMAN'S CAMP, C. 1910. After J. B. Freeman sold Chimney Rock Park, he remained in the area as proprietor of this rustic inn. Freeman would sometimes entertain his guests with a straw ride to pick fruit at a local cherry orchard. Capacity was about 40 guests. This building stood vacant in a dilapidated state for many years and finally was torn down a few years ago.

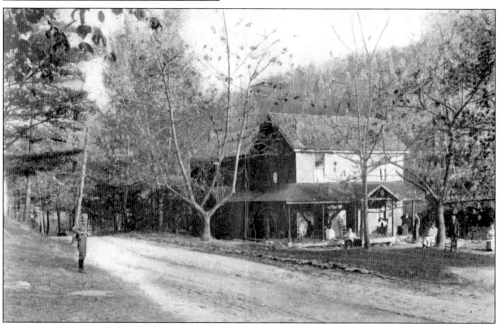

LOGAN INN, C. 1900. Not to be confused with the Harris Tavern (owned for some years by Judge G. W. Logan), the Logan Inn was located in Chimney Rock Village. Its capacity was approximately 40. Also known as Chimney Rock Lodge, it burned in 1930 when windswept flames destroyed nine buildings in one of the greatest tragedies to strike Chimney Rock. (Duke University Library Special Collections.)

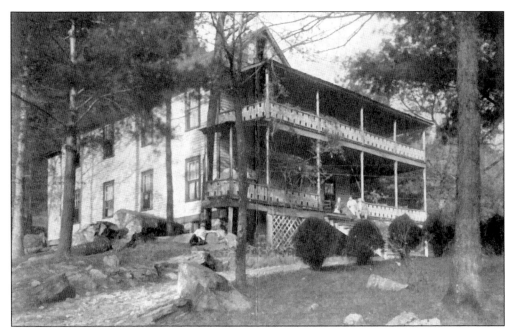

MOUNTAIN VIEW INN, C. 1900. George Pawley Horton (1847–1918) of Wadesboro, North Carolina, built this inn on Speculation Company land across from Chimney Rock Mountain about 1895. It was described as having "commodious and airy" rooms, grounds of about 10 acres in extent, and accommodations for approximately 35 guests. (Duke University Library Special Collections.)

J. M. FLACK, C. 1925. James Mills Flack (1854–1943) acquired the Mountain View Inn from Horton in 1898. As a young man in the late 1870s, Flack had briefly leased and operated the old Harris place, then known as the Chimney Rock Hotel. He left the Chimney Rock section and lived in his wife's hometown of Shelby for nearly two decades before returning.

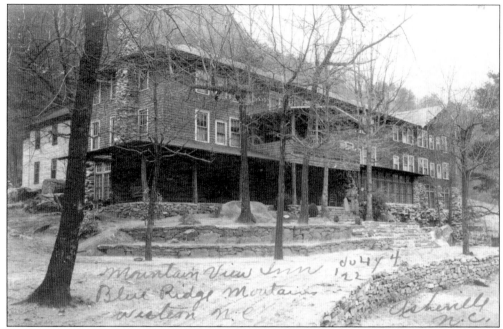

Mountain View Inn
Blue Ridge Mountains
Weston N. C.
Asheville N. C.

MOUNTAIN VIEW INN, C. 1920 AND 1925. Flack eventually enlarged the hotel to accommodate the increase in summer visitors, which was due to the completion of the Charlotte to Asheville Highway in 1915. Horton's more modest building can be seen to the left rear in the above photograph. Some damage was sustained to the older structure during the flood of 1916, but it remained sound. The first addition was actually under way the spring before the flood. Another, smaller addition followed about 1919. In its final form (below), the Mountain View was a rambling hotel of 46 rooms with connecting bathrooms and a capacity of around 125 guests. The exterior effect of the rough boulders used in the construction was sometimes compared with Asheville's famous Grove Park Inn.

DINING, MOUNTAIN VIEW INN, c. 1940. The dining room at the Mountain View Inn sat 120 guests and afforded spectacular views. A 1916 article in the *French Broad Hustler* noted that "Mr. Flack places particular emphasis upon the construction of the new dining room . . . in which will be placed large windows allowing a clear view to be had of Chimney Rock mountain."

This view of Hickory Nut Falls is a part of the delightful mountain panorama seen from the Inn dining room.

LOBBY, MOUNTAIN VIEW INN, c. 1940. In his later years, the elder Flack—known to all as "Uncle Mills"—retired from active management of the Mountain View Inn. But with his flowing white beard, looking every bit the mountaineer, he remained a fixture about the building and grounds. Here he reads in the hotel lobby. Flack remained active until shortly before his death in 1943 at the age of 89.

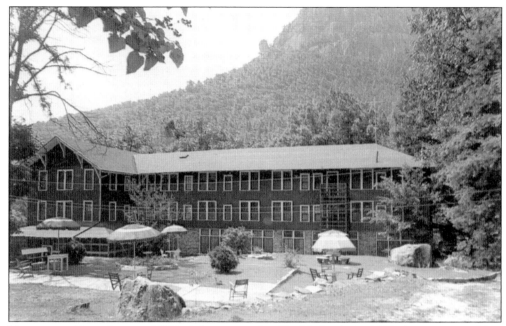

MOUNTAIN VIEW INN, C. 1950. A few years after Flack's death, in 1947, the inn was sold to former Charlotte attorney Kenneth J. Kindley and his wife. Under the Kindleys, the building experienced extensive remodeling. This is obviously a view of the hotel's rear. Tragically, this architectural landmark of the gorge was destroyed in an early-morning fire on May 19, 1956.

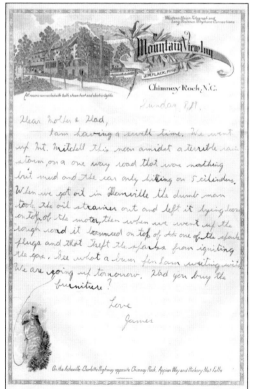

MOUNTAIN VIEW INN STATIONERY, 1929. On the Mountain View Inn's letterhead, the hotel seems literally enrobed in the verdure of the mountainside; at lower left is a vignette of the monolith. The guest who wrote the accompanying letter told of what must have been a frequent complaint among visitors: car trouble. The mountain roads were hard on radiators and tires.

ADVERTISING, MOUNTAIN VIEW INN, 1906. This postcard, with a view from the top of Chimney Rock (probably by A. F. Baker), advertised the Mountain View. J. M. Flack's post office address was given as Bat Cave, which seems a little odd since the inn would have been closer to the post office in Chimney Rock. Picture postcards were a relatively new thing at the time.

GREETING FROM MOUNTAIN VIEW INN View from Top of Chimney Rock

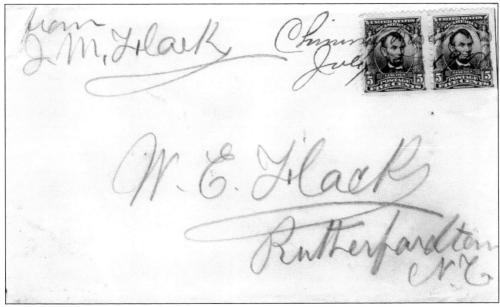

J. M. FLACK ENVELOPE, 1904. During his years before purchasing the Esmeralda, J. M. Flack's son W. Edgar Flack remained in his father's household, no doubt learning the hotel business at the Mountain View Inn. Here the elder Flack has sent a letter to his son in nearby Rutherfordton.

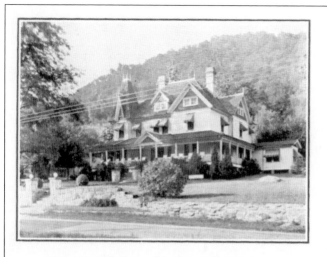

ROCKWOOD INN, C. 1940. Bat Cave's Rockwood Inn, a distinguished building of Queen Anne design, was constructed about 1902 for Adolphus Ervin Hudgins (1864–1936). It began operating as a hotel about 1912 and appears today very much as it did then, having been little modified. Later it was acquired and operated by Mr. and Mrs. John H. Barker and hence became known as Barker's Rockwood Inn.

EDNEY INN ENVELOPE, 1906. This correspondence had to be forwarded because the guest had moved on. The Edney Inn, located just a mile or two west of Bat Cave, was a popular early-20th-century hotel operated by Mark Edney. It reportedly burned one Fourth of July. Another hotel in the section, of which little seems to be remembered, was the Bat Cave Inn.

CHIMNEY ROCK BOYS' CAMP, C. 1930. Pictured here is the entrance to one of several area boys' and girls' camps that had their heyday in the 1920s and 1930s. This one was founded by Rev. George F. Wright, a Baptist minister from Hendersonville, in 1917. Originally called Camp Chimrok, it was located on the side of Chimney Rock Mountain.

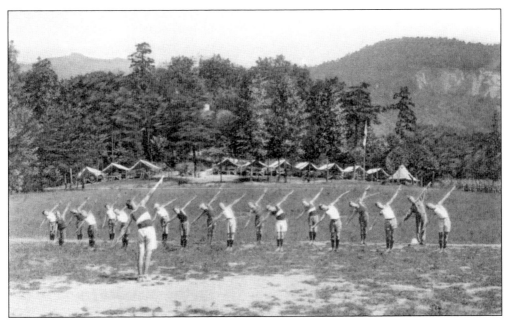

EXERCISING, BOYS' CAMP, C. 1925. In the first year, Reverend Wright brought in a Miami, Florida, man named Reese Combs (1891–1965) to operate the camp. Combs was very involved with the Boy Scouts of America in Miami, serving as commissioner of the organization there. During the following year (1918), Combs apparently assumed ownership of the camp, renaming it Camp Craggy.

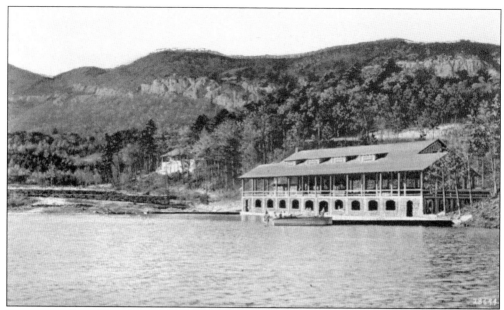

RUMBLING CAVE BAY, C. 1930. By the late 1920s, the camp was called Chimney Rock Camp for Boys and stood along Lake Lure. Combs purchased a large property along the shoreline of the future lake in 1926 and built a modern campground that included a recreation hall, a dining room, a clubhouse, cabins, and tennis courts. The building in the foreground is the recreation hall.

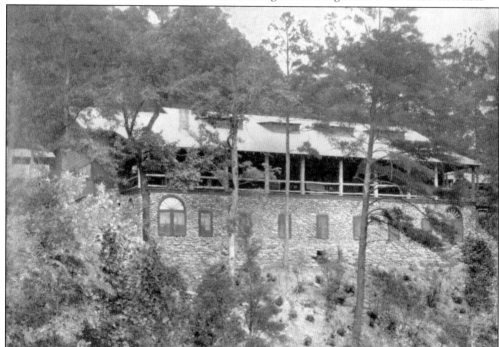

CLUBHOUSE, BOYS' CAMP, C. 1930. The first floor of the clubhouse was used as the camp offices, store, post office, and club rooms. The dining hall was situated on the second floor; constructed of stone, logs, and lumber and rustic in appearance, it was designed with high ceilings and a large rock fireplace. This building was the center of activity at the camp.

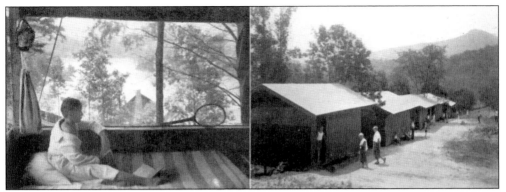

Cabins, Boys' Camp, c. 1930. The camp is best remembered today as a locale for the popular movie *Dirty Dancing*, much of which was filmed in the abandoned facilities there in 1986. When the film became a hit, tourists flocked to see the cabin where Johnny stayed and the bridge where Baby practiced her steps. Now there is virtually nothing left, but visitors still seek out the site.

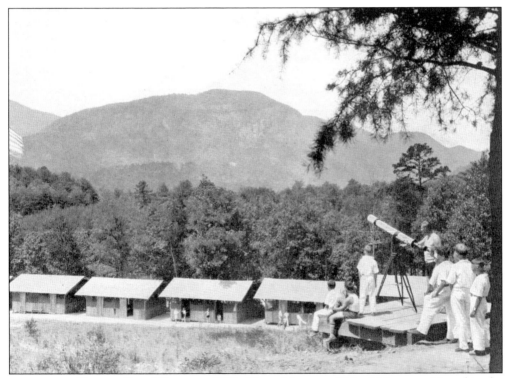

Above the Cabins, Boys' Camp, c. 1930. The cabins were 18 by 24 feet, partitioned in the middle with separate entrances on each side. Each of them accommodated seven boys and a camp counselor. There were separate bathhouses. Compare these dwellings with the crude open-air cabins in the *c.* 1925 image on page 113. Campers in the foreground are using a refracting telescope.

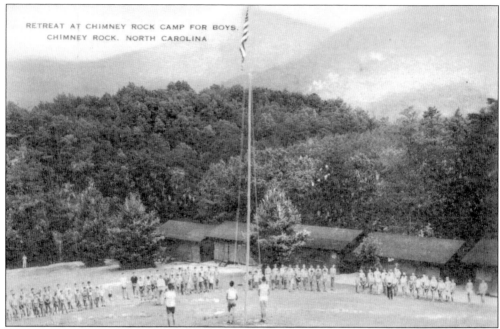

MORNING ASSEMBLY, BOYS' CAMP, C. 1940. Campers were expected to rise at 7:00 a.m. for a 7:15 roll call. Though there was free time, the schedule was very regimented—Sunday school attendance was required, and lights had to be out by 9:00 p.m. The camp typically ran eight weeks, from early July to late August.

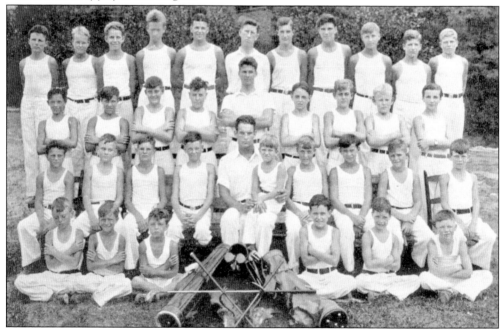

CHICKASAW TRIBE, BOYS' CAMP, 1930. The camp eventually had a capacity of about 150, with most of the boys coming from Southern states, such as Florida, Georgia, and South Carolina. They were divided into four tribes: Cherokees, Shawnees, Chickasaws, and Choctaws. The tribes had athletic teams that competed with one another and sometimes with teams from rival camps.

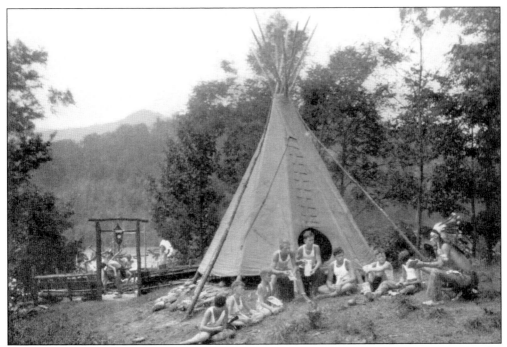

NATIVE AMERICAN LORE, BOYS' CAMP, C. 1930. The boys pictured here listen to a camp counselor in full Native American dress. Tribal lore was an important part of camp life, and the campers enjoyed collecting arrowheads and other relics on the grounds of the camp. To the rear of the teepee is the council ring of the Order of the Woodcraft League, formed for boys under 12.

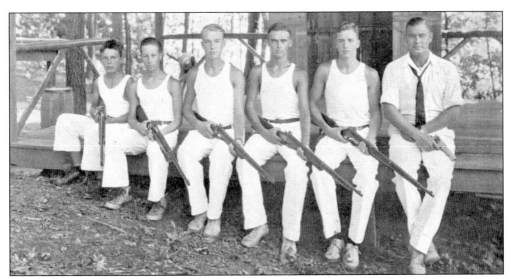

RIFLERY, BOYS' CAMP, C. 1930. The boys engaged in many activities at the camp, including horseback riding, canoeing, making crafts, and playing tennis, baseball, and basketball. These marksmen are dressed in the typical attire of the campers: white T-shirts and pants. Camp literature boasted that they used 25,000 rounds of ammunition per year and that 95 percent of the boys learned to shoot.

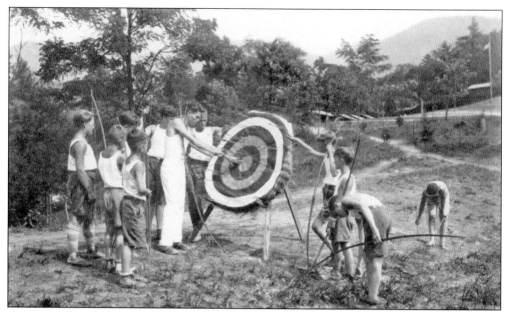

ARCHERY, BOYS' CAMP, C. 1930. The older boys learned to wield 6-foot bows and competed nationally each year with other camps. Reese Combs's archers often excelled. The camp catalog for 1930 noted that "in 1929 the camp placed fifth among about 88 camps participating." The camp also awarded medals to its own expert marksmen.

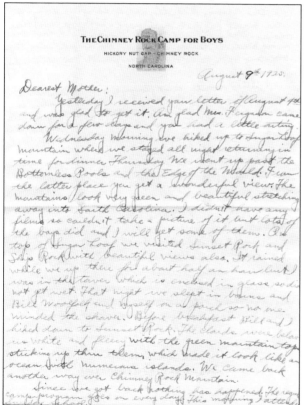

STATIONERY, BOYS' CAMP, 1925. This letter was written by one Allen Kegel, an Iowan who worked as a counselor at the camp. The boys typically took weekly hikes over local mountains, such as Round Top and Chimney Rock, and even made trips to Mount Mitchell and Mount Pisgah. Here Kegel writes of a hike up nearby Sugar Loaf Mountain.

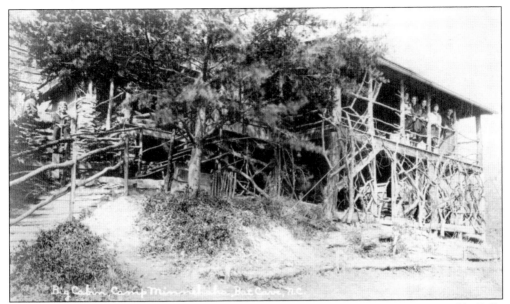

CAMP MINNEHAHA, C. 1930. This popular girls' camp, located near Bat Cave, was started by Belle Abbott Roxby of Daytona Beach, Florida, in 1912. The pictured cabin was used for assemblies as well as cooking and dining. The 50 or so girls who typically came resided in small "cabinettes" that could accommodate 4 to 10.

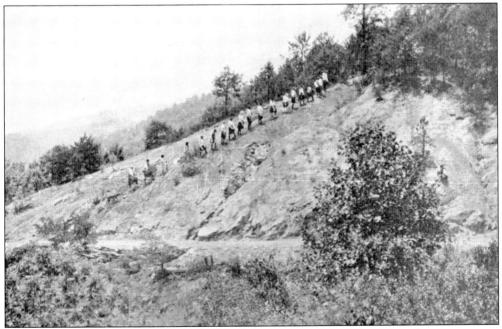

MINNEHAHA GIRLS HIKING, C. 1920. Girls at Camp Minnehaha enjoyed instruction in handicrafts—such as basketry and leatherwork—swimming, tennis, and dramatics, among other activities. The young ladies were divided into Blue Birds (ages 8 to 12) and Camp Fire Girls (ages 12 to 20). The site also functioned as a senior rest camp for adult women.

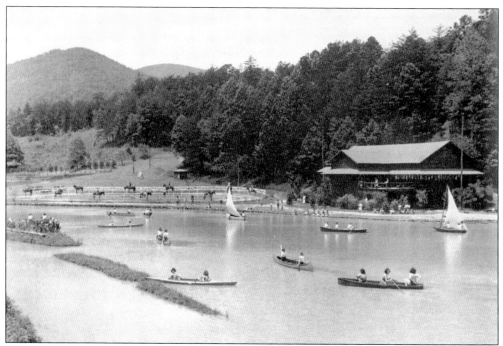

LAKE LURE GIRLS' CAMP, C. 1935. Established about 1928, this camp was very much like Chimney Rock Camp for Boys, though its facilities were probably not as fine. Similar to others in the area, the Lake Lure Camp for Girls embraced a Native American theme. In later years, it was run by Edna Warner.

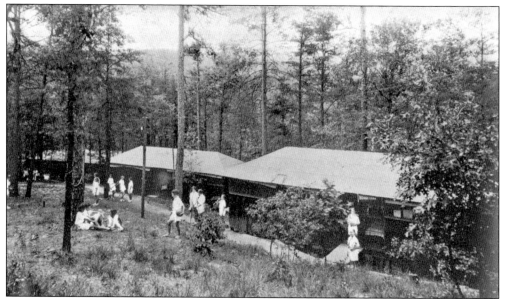

CABINS, LAKE LURE CAMP, C. 1935. The camp's cabins were 18 by 40 feet, partitioned in the middle, and could house eight campers and two counselors. A separate bathhouse and lodge fulfilled the girls' additional needs. The camp's annual season lasted approximately eight weeks during July and August. Most of the campers were teenagers, though there was also a junior camp called the Pebbles.

ROOMMATES, LAKE LURE CAMP, C. 1935. The Lake Lure Camp for Girls placed its emphasis upon personality development and character training. A typical day began with reveille at 7:00 a.m. and ended with taps at 9:00 p.m., but activities were somewhat less regimented than at the nearby boys' camp. Efforts were made to cultivate the individuality of each camper.

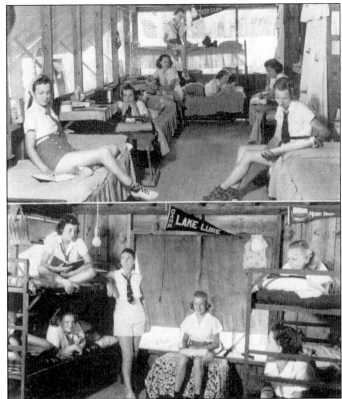

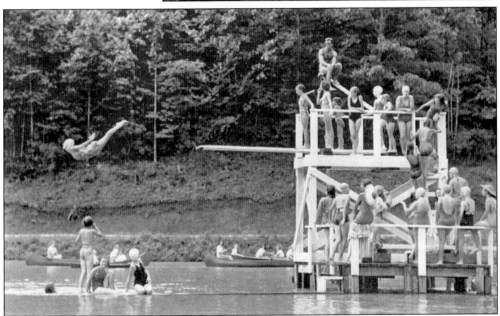

SWIMMING, LAKE LURE CAMP, C. 1935. Campers enjoyed the usual activities such as horseback riding, canoeing, basket weaving, and so forth, but the ultimate purpose was to challenge each camper to the "four Ls" of love, loyalty, living, and leadership. Those who were most conspicuous for these qualities were selected as L Girls during a special candlelight service.

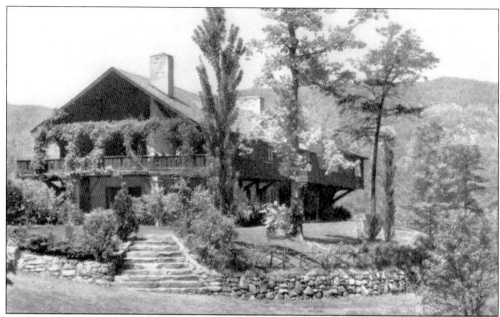

THE CHALET, C. 1940. Located on the side of Pool Creek Mountain, the Chalet, when it was opened in 1934 by Dr. James Murray Washburn, served as a convalescent home for men recuperating from surgery or severe illness. Capacity was then limited to 10. It has for many years been operated as a semi-private resort called the Chalet Club.

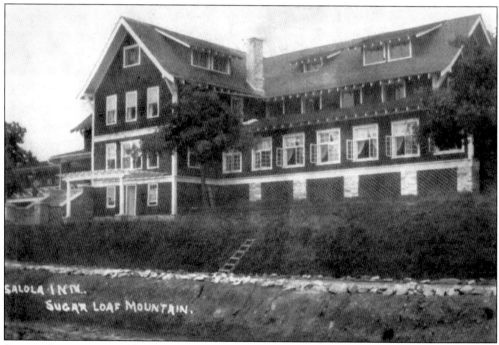

SALOLA INN, C. 1910. This attractive inn, built about 1900, stood at least into the 1950s near Sugar Loaf Mountain. It had 35 rooms, and the grounds included tennis courts and croquet. Over the years, it was known also as Clow's Dude Ranch (1930s) and the Ranch House (1950s). Early owners included Jonathan Williams and J. A. Hooks.

OBSERVATION TOWER, C. 1910. At the start of the 20th century, observation towers were very popular and Henderson County had several. This one on Sugar Loaf Mountain, which afforded fine views of the Chimney Rock section, would have been frequented by guests of the Salola Inn. Sugar Loaf is part of the same range as Chimney Rock Mountain but is located a mile or two to the south.

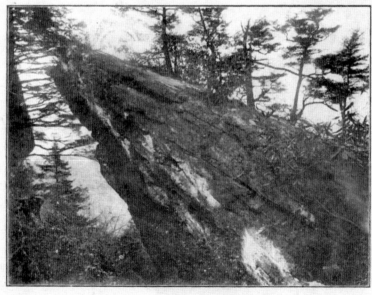

Greeting from
Hendersonville, N. C.

SHIP ROCK
SALOLA MT.

SHIP ROCK, C. 1910. Guests at the Salola Inn could visit granite cliffs and rock formations on Sugar Loaf nearly matching in strangeness and scenic beauty those of Chimney Rock Mountain. Popular destinations for visitors included Cloven Cliff, Squirrel Rock, Sunset Rock, Castle Rock, Salola Bluff, the Pinnacles, the Windows, and Bear Pen Cliff.

MOUNTAIN RUGCRAFT SHOP, C. 1929. The making and selling of souvenirs naturally accompanied the growth of Chimney Rock as a tourist attraction. The U.S. Census of 1930 shows that many natives earned their livelihoods in the souvenir business. The storefront of this shop in Bat Cave displays a number of articles: furniture, postcards, baskets, pottery, and jugs.

WOODPECKER'S SHOP, C. 1929. One of the best-known souvenir artisans in the section was Bat Cave's Carl G. Freeman, alias "the Woodpecker." Freeman had his own workshop, pictured at left. Articles made from native rhododendron were a specialty, as evidenced by the young lady in the middle photograph who is lettering some of these. Working from native wood, artisans made everything from letter openers to telescopes.

ROCKY BROAD COTTAGES, C. 1940. Not everyone stayed in a big hotel like the Mountain View Inn. Some preferred the comparative privacy of cottages like these, which were operated near Bat Cave for many years by Mr. and Mrs. W. H. Garvin. Units ranged in size from one to three bedrooms and included kitchenettes.

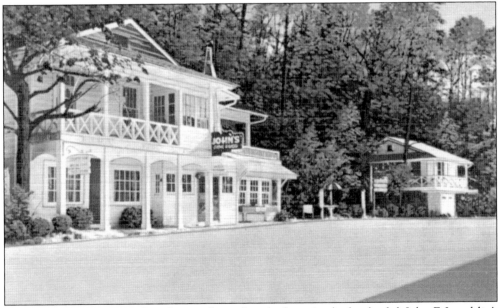

JOHN'S TAVERN, C. 1940. Last but not least, famished tourists had to be fed. John F. Laughlin's tavern, located in the village of Chimney Rock, was *the* place to eat between Rutherfordton and Asheville during the 1930s and 1940s. The restaurant served barbecue, steaks, "butter toasted sandwiches," fried chicken, and more. Laughlin also rented cottages.

BIBLOGRAPHY

Asheville Citizen Times. Asheville, NC: 1890, 1916, 1946.

Cole, J. Timothy. *The Rumbling Mountain of Hickory Nut Gap: The Story of North Carolina's Most Celebrated Earthquakes.* Wilmington, NC: self-published, 1990.

Colton, Henry E. *Mountain Scenery: The Scenery of the Mountains of Western North Carolina and Northwestern South Carolina.* Raleigh, NC: W. L. Pomeroy, 1859.

FitzSimons, Frank. *From the Banks of the Oklawaha, Vols. 1–3.* Hendersonville, NC: Golden Glow Publishing Company, 1976–1979.

Forest City Courier. Forest City, NC: 1924–1927.

French Broad Hustler (title varies). Hendersonville, NC: 1913–1918.

Griffin, Clarence W. *The History of Old Tryon and Rutherford Counties, 1730–1936.* Asheville, NC: Miller Printing Company, 1937.

———. *Western North Carolina Sketches.* Forest City, NC: Forest City Courier, 1941.

Ilsen, Maude. *Chimney Rock Anthology.* Publication *c.* 1920.

Lanman, Charles. *Letters from the Allegheny Mountains.* New York: G. P. Putnam, 1849.

Matthews, Dr. James F., et al. *Chimney Rock Park Nature Trail Guide.* Published *c.* 1980.

Mills, Quincey Sharpe. *Editorials, Sketches and Stories.* New York: G. P. Putnam's Sons, 1930.

Patton, Sadie Smathers. *The Story of Henderson County.* Spartanburg, SC: Reprint Company, 1982.

Speculation Land Company Papers, No. 2876, Box 3, Folder 63, Southern Historical Collection, Wilson Library, University of North Carolina at Chapel Hill.

Zeigler, Wilbur G., and Ben S. Grosscup. *The Heart of the Alleghenies or Western North Carolina.* Raleigh, NC: Alfred Williams, 1883.